THE ART OF

Children's Portrait Photography

TAMARA LACKEY

AMHERST MEDIA, INC. ■ BUFFALO, NY

About the Author

Tamara Lackey is an award-winning photographer based in North Carolina whose images have been described as expressive, authentic, and moving. She has won multiple awards from WPPI (Wedding and Portrait Photographers International) and has been selected as a WPPI 16x20 print competition judge in two categories.

Her work has appeared in a variety of magazines, including *Vogue, O Magazine, Elle, Town & Country, Martha Stewart Living, Parenting, Food & Wine, The Knot Weddings, Premier Baby & Child,* and *Inside Weddings.* She regularly shoots the cover images for *Adoptive Families Magazine, Endurance Magazine,* and *Carolina Parent.* Her photography has been showcased on the *Martha Stewart Show* and her stock images are sold worldwide.

Tamara has been featured on several occasions in *Rangefinder* magazine and regularly speaks at seminars and photography conventions throughout the country.

Published by:
Amherst Media, Inc.
P.O. Box 586
Buffalo, N.Y. 14226
Fax: 716-874-4508
www.AmherstMedia.com

Publisher: Craig Alesse
Senior Editor/Production Manager: Michelle Perkins
Assistant Editor: Barbara A. Lynch-Johnt
Editorial Assistance: John S. Loder, Carey A. Maines

ISBN-13: 978-1-58428-240-2
Library of Congress Control Number: 2008926655

Printed in Korea.
10 9 8 7 6 5 4 3 2 1

Table of Contents

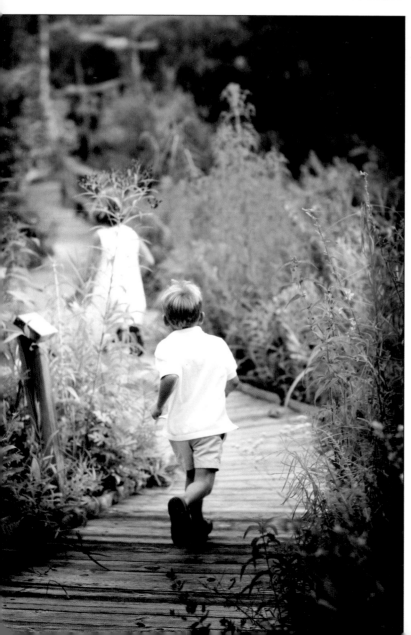

The Spark That Fuels a Profession

"It's never too late to be who you might have been."

—*George Eliot*

I love this quote. It is such an incredibly empowering statement and, if read with the just the right-sized open mind, it can propel you to motivate yourself toward any goal, at any time.

Some people will tell you about how their earliest memories involved toddling about, age three, camera in hand, snapping away at everything and everybody, and how to this day they haven't put that camera down. Others will relate how they always had an appreciation for art, for creativity, but didn't discover that their particular medium was through photography until they took that one photograph and saw the possibility of who they could become.

Still others had no creative background whatsoever, no real appreciation for art actually, but they experienced some life event that inspired them to pick up a camera with a new appreciation for what it could capture. An often-heard inspiration is the birth of a child. Another is a response (be it good or bad) to your own wedding photographs or family portraits. Another may be a striking realization; an afternoon spent sifting through old photographs at your grandmother's funeral can cause you to understand for the first time how powerful images are, how much they can live on as actual markers of one's existence.

The important thing is that something has to happen next; that spark, however robust it is, has to be strong enough to fuel a profession.

For me, the spark occurred when I was participating in a simple exercise that was designed to get you to think about what it is that you would really love to do with your life. The exercise was as follows: assume you only have one year to live. Don't worry about any medical aspects of this year, just concentrate on looking at the next and final year of your life and decide exactly what you want to do with it. I was asked to think of ten incredibly important things that I wanted to do before I died. Really paying attention to this effort was eye-opening for me. Most of the things on my list were grand, large-scale ambitions (still ramping up for that marathon in Antarctica!) but one of the ten items was a pretty simple listing. I wrote: The Perfect Family Photograph.

That one was simple but a bit tricky. I wanted to have the perfect family photograph of my own family, but I also really, really wanted to be the one to shoot it. It struck me then how difficult it was to achieve the "perfect" family photograph because of what exactly

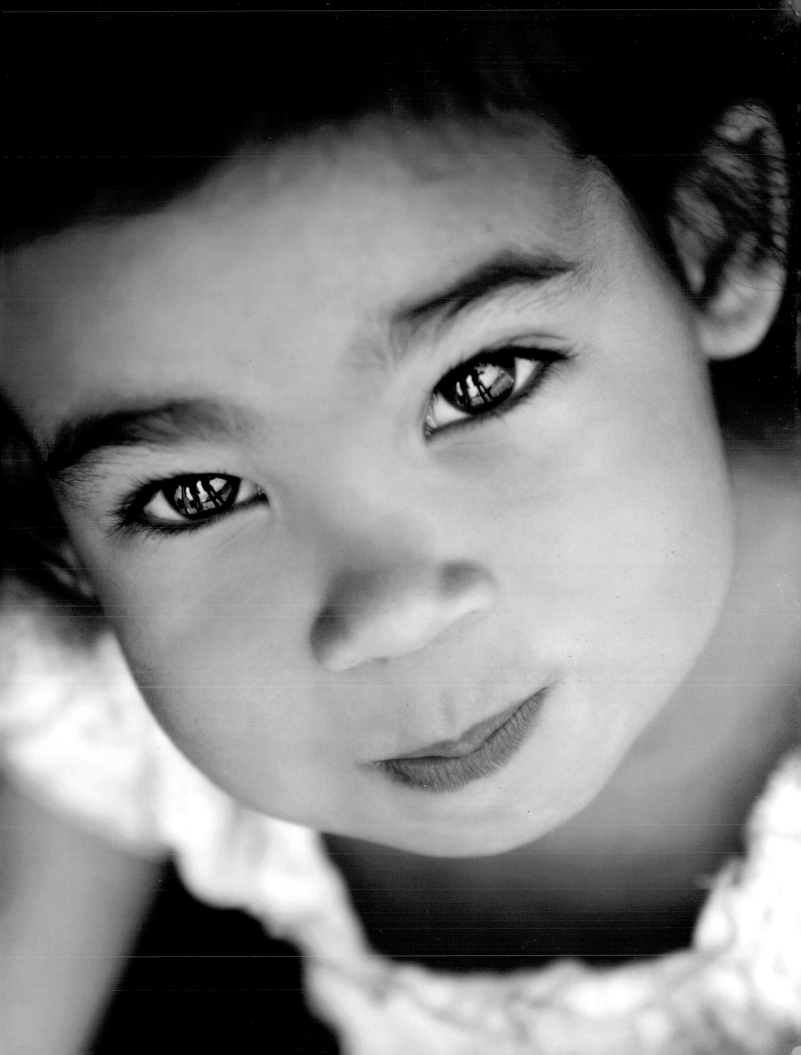

that word meant to me. Certainly the exposure would have to be excellent, the clothing had to work well, and the setting was important. Mostly, though, I wanted each person in my family to be authentically represented. I wanted to see that alluring combination of gentleness and strength in my husband . . . but I also wanted his hair to look good. I wanted my daughter's nose crinkle to appear when she did that full-out belly laugh, but I wanted her head tipped forward more so I could maximize the catchlights in her huge eyes. I wanted my dog to give me those fantastic tongue-out smiles of hers, but I knew that I needed to grab the image the second that she leaned into my husband with such sweet affection, since it would also be just a moment before she would completely flop over on him and demand a belly scratch.

What I wanted was not just the perfect photograph of their appearances but the perfect moment that showed everything about them that I loved. The more I thought about that, the more I realized how much I would love to do this for not only my immediate family, but also my extended family . . . and for my friends' families. I knew that "comprehensive capture" could be something a lot of people would truly love to own—their perfect family photograph. And it struck me then just how much I truly loved the challenge of authentic, beautiful photography. That realization fueled a new profession.

Summary of Business and Studio Growth to Date

Before I realized I was a photographer (!), I had a whole different life. I graduated from Miami University, majoring in mass communications with a minor in art history. The good news was that I had graduated with the top of my class. The bad news was that I had a ton of student loans to repay—and I didn't want to be still paying them more than twenty years later. As

a result, I did not choose to follow my passion for art and instead accepted an offer with a major management consulting firm.

By working for Accenture, I ended up receiving a great education in business fundamentals as a Change Management Consultant, primarily focused on the people side of business change within major corporations like AT&T, with whom I worked for several years. Learning concepts such as the tactics behind process improvement (basically, studying the series of actions required for a particular goal and determining the most streamlined way to perform it) enabled me to recognize how many organizations rely on an ad-hoc approach to managing the same things they do every day. Without giving due attention to exactly what you are doing and realizing the effect step one has on step three, you can end up making new rules as you go along or making adjustments to your process flow daily—just on the fly. Putting in place standardized systems for process flow and, more importantly, getting people to buy into following prepared processes save significant time, effort, stress, and ultimately money.

I learned a lot about savings. I learned that the more time you save, the more of it you have to spend with friends and family. The more effort you save, the more energy you experience in your every day life. The more stress you prevent, the more you enjoy your work and the people with whom you come into contact every day. And the more money you save, the more you recognize higher levels of profit, thereby securing the future of your profession and increasing your self-worth, confidence, and overall happiness with your work. And every one of those savings—time, effort, stress, and money—will directly translate into additional revenue in your business.

This concept of utilizing documented processes to work smarter instead of harder would mean so much more to me years down the road. When I started a small business as a photographer, I found myself wading into a profession that was just begging to be managed by sound organization.

What You Are About to Learn

Not to talk this book up too much, but I so wish there had been a guidebook as comprehensive as this when I was starting out in photography, especially when I was I was trying to figure out my basic workflow as a new photographer, and even more so when I was in the process of building out my studio. There is just so much to know—and so much to avoid! You will find this to be an excellent resource for either starting a new profession or simply building on an existing one to create a more fulfilling and successful business.

The more time you save, the more of it you have to spend with friends and family.

Of course it is key to learn the basics of photography (or to learn to excel at what you already know), but I can't overstate the importance of aligning your business in the correct fashion to streamline all the little things that can add up to extra hours of work every day. Learning exactly how to work smarter versus harder, with practices specific to the photography profession, can not only be a fantastically liberating experience, it can also help you enjoy your work more now and for years to come.

1. Contemporary Children's Photography

What is Contemporary Photography?

You hear a lot of phrases used to describe the contemporary look in portraiture. These descriptions are often positioned in direct comparison to a general perception of traditional photography: less posed, less stiff, more natural, more expressive.

Contemporary photography is generally considered to be a fresh and unique approach to traditional portraiture; it is viewed as more groundbreaking in its approach to finding new and exciting ways to capture subjects. The use of more dramatic black & white tones, with an emphasis on platinum hues and warm chocolate tints instead of simple grayscale images, is a common feature of contemporary photography. Color images also tend to be represented more vibrantly; scenes are displayed in higher contrast, often with interesting textures. A liberal usage of special techniques, such as sunbursts, eye-catching compositions,

Compared to traditional portraiture, contemporary portraiture is less posed, less stiff, more natural, more expressive.

and dramatic vignettes, is also common. Another trademark of contemporary photography is the utilization of strong, clean close-ups, and subjects are frequently shot with wide angles and an increasingly shallow depth of field. There is often a liberal use of refined but controlled Photoshop processing, as well.

More importantly, contemporary photographers highlight the importance of storytelling and emotion, and there is a great importance placed on relationships. Also called lifestyle photography, this style is not only about *how* you capture, but also *what* you capture—"more moments in time" as opposed to "manufactured illusions." A contemporary photographer is just as likely to photograph a child's tantrum as their big, toothy smile. Contemporary portraits are meant not only to capture one's likeness, but actually to reflect one's personalities—tantrums, daydreams, goofiness, quirks, and all.

Another hallmark of the accomplished contemporary children's photographer is an openness to venue. Contemporary photographers are able to shoot anywhere, and the best are skilled at working with natural light. As a result, they are constantly looking for creative ways to make the best of their locations.

A common response to this type of photography is often the joy of recognition; you hear a mom say, "That's so him!" or "Look at that! I love how we

Contemporary photographers highlight the importance of storytelling and emotion . . .

laugh together." Instead of being told to sit still, children are told to play, to be free, and to interact with each other naturally. Contemporary photography is a blend of anticipating the moment, finding the backgrounds, and controlling the light to create strong, dynamic images.

Children are told to play, to be free.

What Contemporary Photography is Not

Contemporary photography should not be the equivalent of creating stock photography for a family. On stock photography shoots, you are mocking up emotions and responses, using phrases like "You are so happy to be together" and "You are laughing at what he is saying" in order to illicit the exact response you want to portray in the image.

At the root of contemporary photography is capturing genuine emotion. Thus, part of your job as a photographer is to bring an intuitive spirit to the process so that you can learn, through dialogue and

observation, what your subjects are all about, what they are to each other. Then, it's your job to get them to trust you enough to capture them honestly.

There are times when you will find yourself on a shoot where Mom or Dad says something to their child that goes completely against the grain of what you are trying to accomplish, which is capturing a genuine response. You may hear shout outs of "Laugh with your brother!", "Say cheese!", or "Be happy or no ice cream!" When this happens, it is highly likely that the parents simply do not understand exactly what it is you are going for during the session. Many individuals can look at photography, know they are drawn to a certain style or a particular photographer's work, but in no way express why—much less how it might have been created.

Therefore, it's also your job to prepare your client ahead of time, explaining that your goal is to capture the actual experiences and emotions as they unfold or even as they are honestly coaxed from a subject. If they are with you on this, they are usually less apt to try to control the outcome and responses. If necessary, you can always respectfully remind them that they hired you because they were drawn to your work, and that work is a product of your methods. It's no fun to have to ask parents to stop issuing their requests; with a little education on your methods, how-

ever, you can avoid many disruptions in the harmony of the shoot.

Why Traditional Portraiture Still Matters. A Lot.

Knowing the rules of traditional portraiture, which is more controlled and usually less spontaneous than contemporary portraiture, will benefit you greatly when shooting lifestyle portraits. Because there is a lot of careful thought and planning put into designing each traditional picture, success requires a solid understanding of the rules of lighting, posing, and composition—the fundamental elements of the art. In lifestyle photography, you will also want to strive for those same artistic goals, but instead of planning each of the elements, it becomes your responsibility to capture them instantly as a moment naturally unfolds before you.

In fact, because contemporary photography relies so heavily on active observation, it is possibly even *more* critical that you learn the techniques associated with traditional teachings. This is especially true when it comes to lighting. Great lighting is an incredibly important part of photography—the word literally means painting or drawing with light (from the Greek roots *photos* [light] and *graphos* [writing]). Learning how to harness and control light properly and confi-

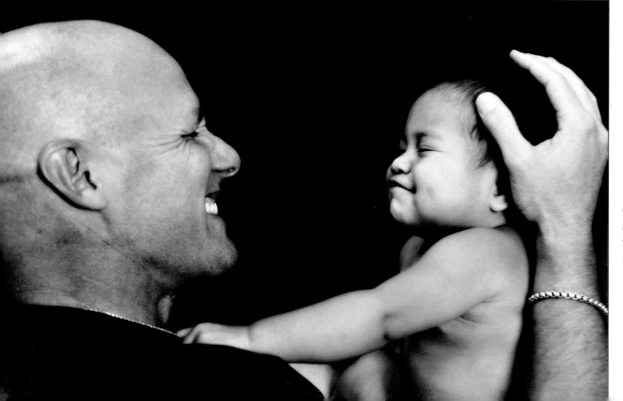

Genuine responses and emotions are at the heart of contemporary portraiture.

dently will help you with every facet of your artistic career.

Why does it matter to know what has come before? Photography is art. It's taken decades for it to be universally recognized as such, but photography is absolutely regarded as art today. So, to take an analogy from painting, no matter how wonderful your creative vision, you still need to know the basics of proportions to bring sketches to life.

Once you have reached the point where the creation of art just flows, where you know the rules so well that you no longer have to think about them, this is when you can confidently practice your craft. With enough knowledge and practice, you will reach a point where it becomes effortless. You can photograph your subjects exactly how you want them to be captured, easily moving between lighting changes, swapping out lenses on the fly, and responding with ease to the scene as it unfolds before you.

When you reach that point, you can then become even more daring and inventive with your work. As the old phrase goes, "You need to know the rules before you break them." It is arguable that in contemporary photography it is even more important to learn the rules of traditional portraiture, as there is less you can control when you are trying to capture the unknown in a new and fresh way. Photographing something differently just for the sake of being different doesn't always mean it will be compelling or interesting. When you photograph something in a way that draws the viewer in, in a way that is innovative and memorable and truly original, you are also likely to find that you have also managed to harness many of those traditional philosophies—but with your own personal view and your own modern twist.

Yes, you can absolutely go out and shoot and then work to "fix it" in Photoshop; many photographers do. However, the image is always cleaner when you shoot for proper exposure in-camera. Additionally, when you pair the fix-it-in-Photoshop approach with

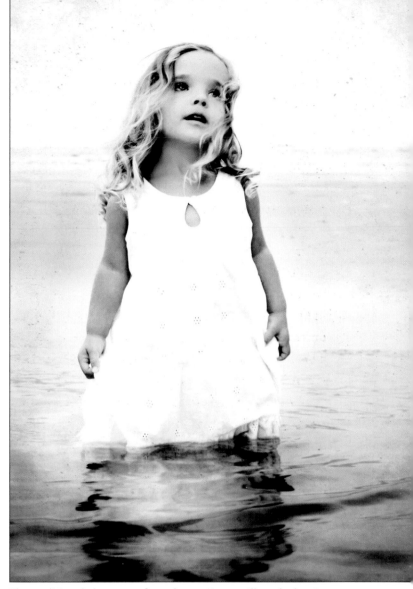

The traditional elements of good portraiture still apply, but in contemporary styles you are more likely to capture these elements as they occur naturally (rather than planning and executing them).

a full workload (ten portrait sessions to deliver in the next two days!), it will not be long before you will be far too overwhelmed to keep fixing images after the fact—if you are not already feeling that way.

2. Working With Children

"Do you know what you are?
You are a marvel. You are unique.
In all the years that have passed,
there has never been another child like you."

—Pablo Casals

Children are such a marvel. Really. This little being with its own physical features, personality, its own specific shade of eye color seems to come into this world from nowhere. Of course, children come from somewhere—some say heaven, some say uterus, some say a twinkle—but no matter what your beliefs, a new child is the biggest miracle we know.

To bring a child into your own life is nothing short of astonishing. I have birthed one child and adopted one child. In both cases, they were the most dramatic moments of my life.

When I talk to new mothers, many of whom I photographed while they were pregnant, they tell of the birth experience, the new adjustments at home, the semi-shock at this whole new being. This is *their story*; they have experienced an unbelievable transformation from women into mothers and are still reeling a bit from what it all means. It's no different for men. When new moms come to the studio, they bring along with them the starry-eyed fathers who feel such

an indescribable accomplishment, who just moon over this new being, who point out all the unique qualities of their adored progeny.

We, as photographers, have the incredible responsibility of capturing the great drama of their lives, and it is truly an honor and a privilege to do so.

"You're So Good With Kids!"
(How To Draw Out Every Child)

There are two great methods to utilize when preparing for working with a child. The first is to do a little homework on them. Learn what that particular child responds to best. There are two methods for accomplishing this.

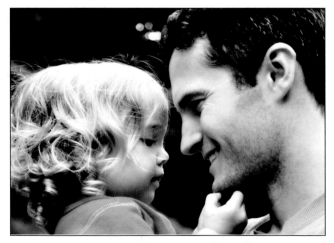

ABOVE AND FACING PAGE—Gaining your subjects' trust is critical to capturing the intimacy of significant relationships.

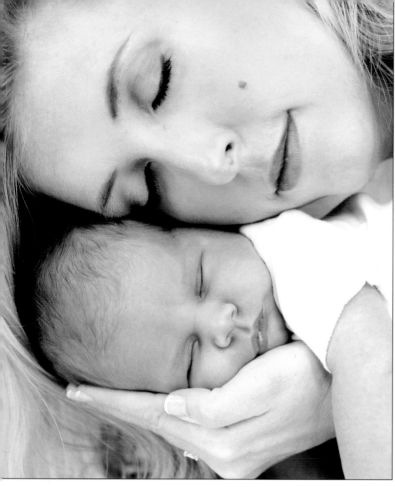
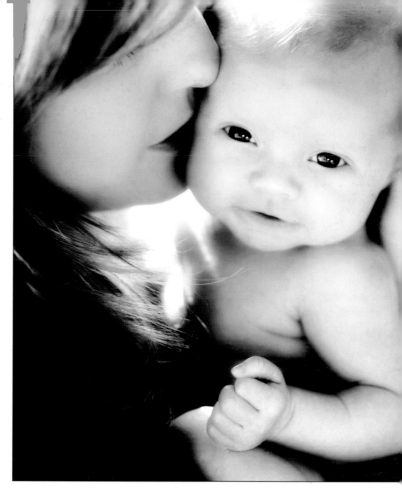
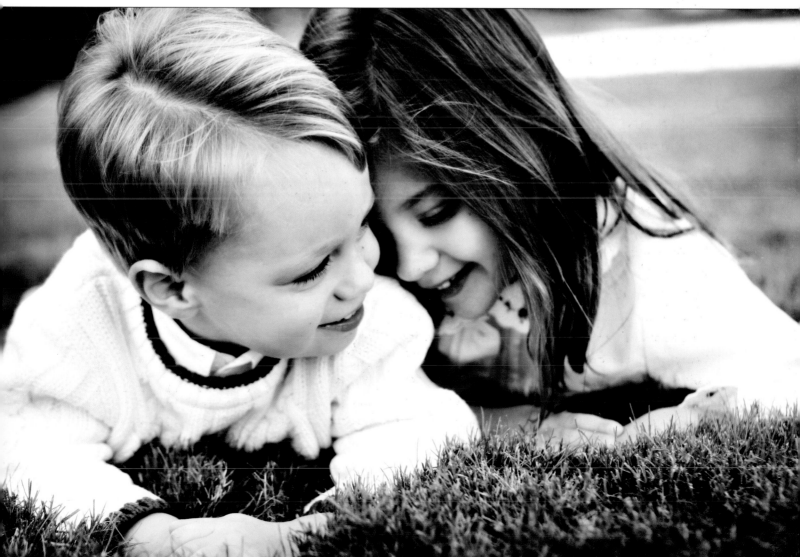

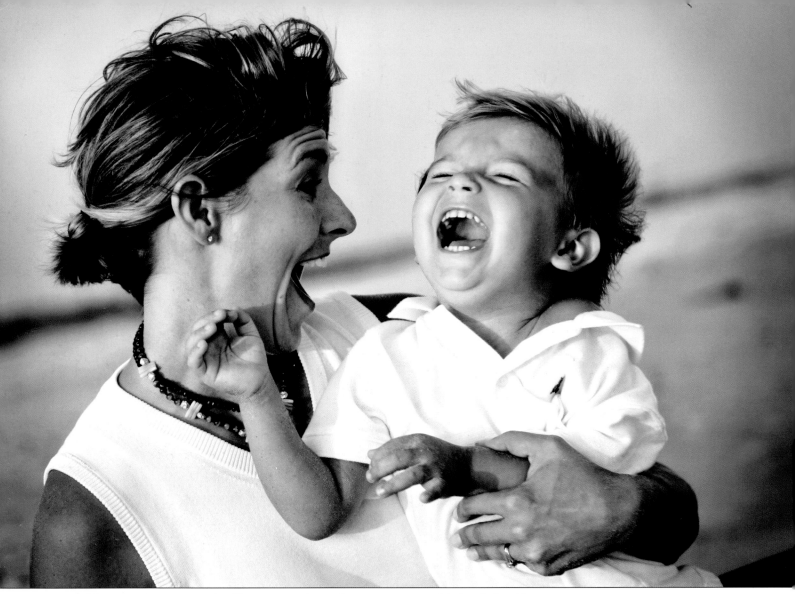

When people trust you, they'll open up and reveal the true nature of their relationships.

The best and simplest way to find out this information prior to the actual session is just to ask the parents. There are some great sample questions listed on the facing page. Using these, you can learn not only who you are photographing but also how best to photograph them. You'll learn how to position yourself as one who can be trusted to photograph the intimacy of significant relationships, like the parent–child connection and the sibling bond.

The second method is simply to tune in when you meet the child. As you increase your experience working with children, you will get better at this. By studying different personality types you will learn how to recognize unique traits in your subjects and hone in on them during a shoot. For many, this comes naturally; they are very interested in meeting children and learning more about what makes them tick. For others, people who tend to be more interested in the photography aspect of the shoot, there may be less of an intuitive connection with the child in front of them. This does not mean you cannot still draw them out, though. You just need to learn more about how to recognize consciously what others might naturally sense.

Observe and Ask Questions

Even though children may seem to fit very much into one type, by and large they are pretty unique. Just

when you think you might have them pegged, they exhibit a behavior you haven't seen before.

Honing two skills can give you the advantage. First, you can learn to tune into your own intuition, which has probably served you quite well so far, to really get a handle on just who this person is. Second, you can learn how to get a good read on most kids' personality blends—enough, certainly, to get you through a portrait session. This will give you the additional advantage of knowing how to tap into the child's dominant personality type within their personality blend and, therefore, connect with them as best you can to really photograph their authentic selves.

So, to start, find out what makes them who they are. What are their quirks, their likes and dislikes, what fascinates them, and what can set them off? Chances are, you'll learn something significant and you can adjust your behavior accordingly. Asking detailed questions up front can save you a misfire during the shoot. For instance, you learn from Mom that her eighteen-month-old daughter breaks down whenever she is startled, you know to skip the peek-a-boo game.

It always helps to have these conversations before the day of the shoot, but you should also build some time into the beginning of your session. This gives you an opportunity to watch the child for a bit before you start the actual shoot. The following are some things to ask about and look for when assessing a child for the first time. Asking a series of questions like these will only take about five to ten minutes, but the answers can arm you with significant advantages when you are photographing your subject.

1. Given that we are starting the shoot just after he has been awake for about an hour, how long do you think we'll "have"? Will he be at his best when we first meet, or do you think he'll need a bit more time to perk up?

2. Does he like to be the center of attention, or does he prefer to blend into the background?

3. Is he calm, quiet, and pensive, or loud and full of energy—or somewhere in the middle?

4. Does she seem to daydream or space out easily? Or is she alert, focused, attentive, and interested?

5. Does he cry easily? Is it a quiet, snuffly cry, or an ear-shattering, vigorous one? Or is he not likely to show you a negative emotion but just to withdraw instead?

6. Is she affectionate, cuddly, and demonstrative with her feelings? Or is she independent, demanding her own space and preferring less physical contact?

7. Is he immediately excited about new things and places and adventures? Or does he need to take it slowly? Or is he greatly resistant (i.e., "never" comes around)?

Look for what makes your subjects who they are.

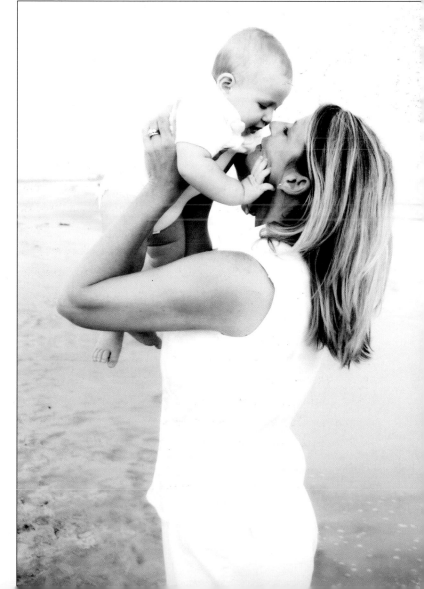

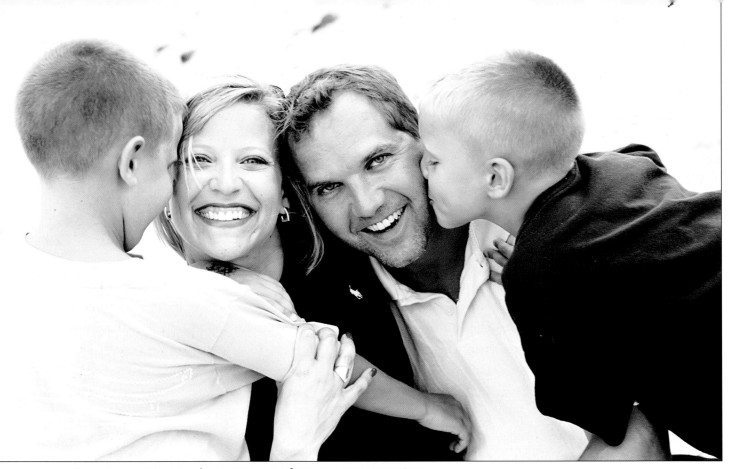

Capturing emotions is a key component of contemporary portraiture.

You may already have been taking in a general sense of these behaviors, but honing in a bit with feedback from the parents can really make a difference in the quality of the expressions you can capture and/or elicit from the child. Just as you wouldn't play peek-a-boo with a child who does not like to be surprised, you wouldn't ask big brother to smother his little sister with kisses if that kind of activity violates her personal space or makes her feel trapped. Similarly, if you know that a child will exhaust quickly—that you'll probably only have a good half hour—you can start the shoot actively, capturing the smiles before the child's mood goes south.

Personality Typing

Personality typing is an impressive technique to be able to use when working with children. There are a number of ways to utilize "typing," but one of the most widely recognized and accepted methods is the Myers-Briggs method, originally created by Carl Jung and expanded on in great detail by Katharine Meyers and Isabel Briggs Meyers. A fantastic resource for using typing with children is the book *Nurture by Nature*, written by Paul Tieger and Barbara Barron-Tieger (Little, Brown and Company, 1997). They describe typing as "a system for understanding the very different operating styles people have." According to this theory, there are four dimensions that make up a person's personality type:

Extroverted/Introverted
 (or how people are energized)
Sensing/Intuition
 (or what kind of information they
 naturally notice and remember)
Thinking/Feeling
 (or how they make decisions)
Judging/Perception
 (how people organize the world
 around them)

There are many reference sources, in print and on-line, through which you can easily familiarize yourself with the detailed definitions of these components of various personalities. By doing so, you will able to more easily recognize who you are dealing with when you meet a child for the first time. One of the most fascinating things about personality typing is how two people who share three out of four of these components can actually have extremely different personalities simply based on that one different component.

Recognizing Personality Types and Blends

The Performer or Superstar. This child can be a blast to photograph. Typically high-energy and smiley, this child is usually up for anything. You'll hear a lot of, "Take my picture doing this! Watch me now! Look at this!!"

This child is a lot of fun, but you need to beware of the performance factor. You'll get a lot of "Say cheese!" smiles, which is something you want to avoid with the contemporary look. Your goal is to go after their natural smiles, their authentic excitement. With natural performers, that look is often captured after

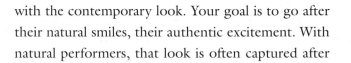

Their more natural smiles occur while they are planning their next performance . . .

they give you the big smile. Their more natural smiles occur while they are planning their next performance or when they shift their attention away from their own act and are pleasantly distracted by something else that is entertaining to them. You can *be* that distraction by engaging the child in a conversation that is fascinating to him—and it's often a "him."

Move your camera away from your face often, so that they can tell you a story. And try to shoot seamlessly, without breaking the conversation, regardless

The classic oversmile. And . . . wait for it . . .

The genuine smile.

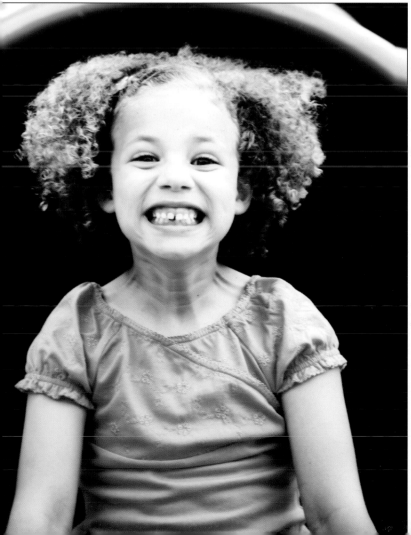

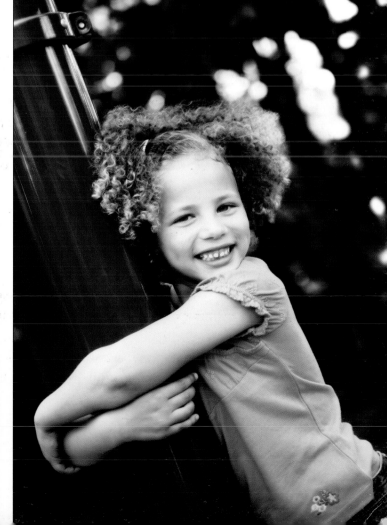

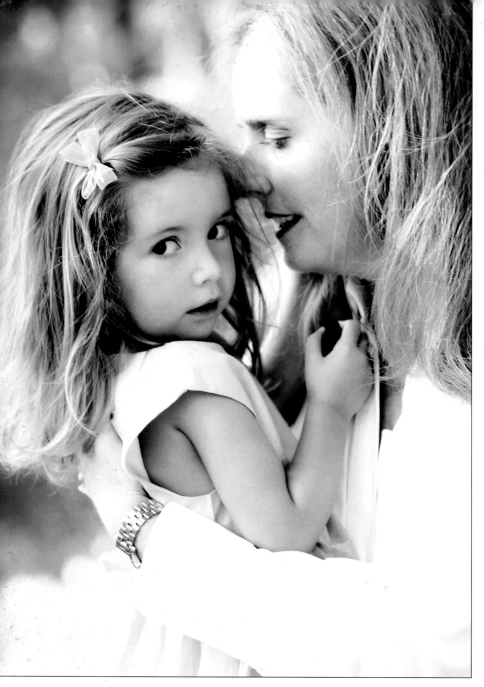

A careful assessment.

when you are presenting the full shoot to your client.

The Shy One. This child is truly shy. She may warm up slightly during the shoot but will probably never be the one laughing uproariously at your silly faces. The big plus here is that you are more apt to capture those fabulous soulful looks—the big, questioning eyes as they carefully assess you, or the dramatic, thick sweeping of eyelashes as they look away nervously. When you do achieve a sweet smile or a spontaneous giggle, the effect can be dramatic.

What is important with the very shy child is to treat her cautiously, to be soft, gentle, and to win her trust. Watching the tone of your voice here can have more of an effect than you may realize. Try to stay gentle and encouraging. Keep in mind that very shy children may have received less attention over time, simply because others think that they want to be left alone. By remaining gently interested in them and sharing some of yourself along the way, you can often capture their interest.

This is why it is so important to get a great feel for who exactly you are photographing: what works wonderfully for the superstar can completely backfire with the very cautious child.

of who is speaking. You can still photograph some dreamy expressions from the performer, but these are usually captured toward the end of the shoot, when they may have finally wound down a bit, or when they are looking to their next adventure.

The big hint here is to not put your camera away until you are truly away from this child, as some of those exhausted "zone outs" can provide a wonderful complement to the laughing and giggling images

The Interactive One. The interactive child likes the give and take of exchanges with companions. They are inquisitive, interested, and usually know a lot of wonderful facts that they love to recite ("Did you know that the East African lizard pup will eat up to three times their weight in the first week of their life?" [a completely made-up fact]). This child also asks why—a lot—and has tons of interesting stories to share.

Those soulful expressions.

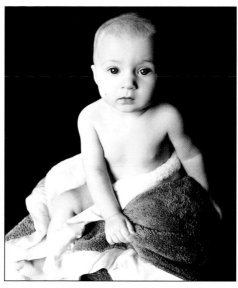

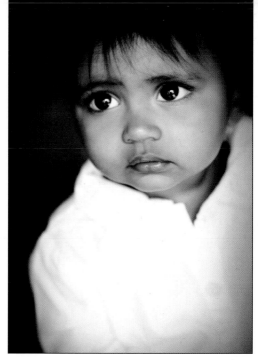

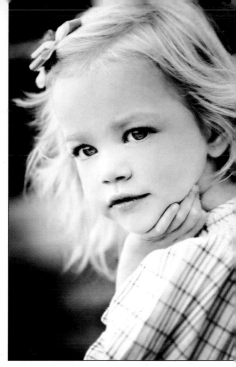

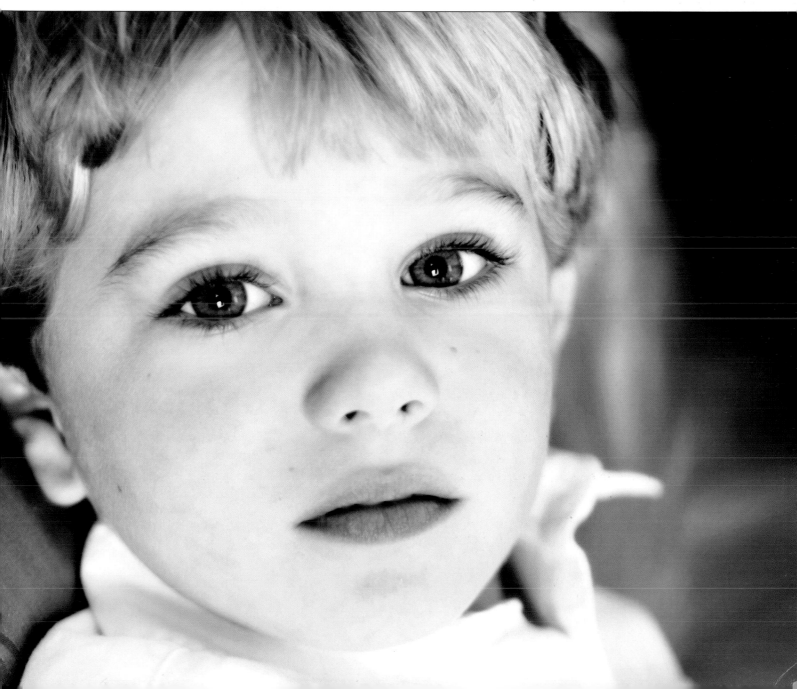

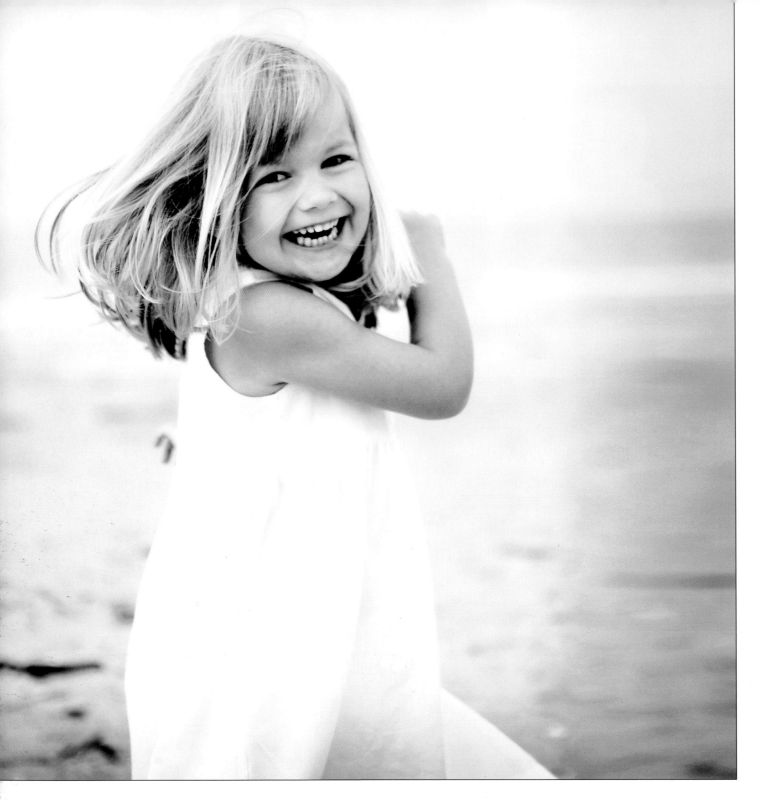

You will most likely be able to capture a great number of intense looks and expressions, as they cock their head to one side to listen to what you say, with wonderful eye contact and rapt attention. You also get some beautiful smiles as they wrap up their latest story and can't help but notice that you share their total fas-

ABOVE—In motion and still in touch. **FACING PAGE, TOP**—Wonderful eye contact and attention. **FACING PAGE, BOTTOM**—Interested even in repose.

cination with the Wing-Tipped Rubber Goose Dog (also totally fabricated).

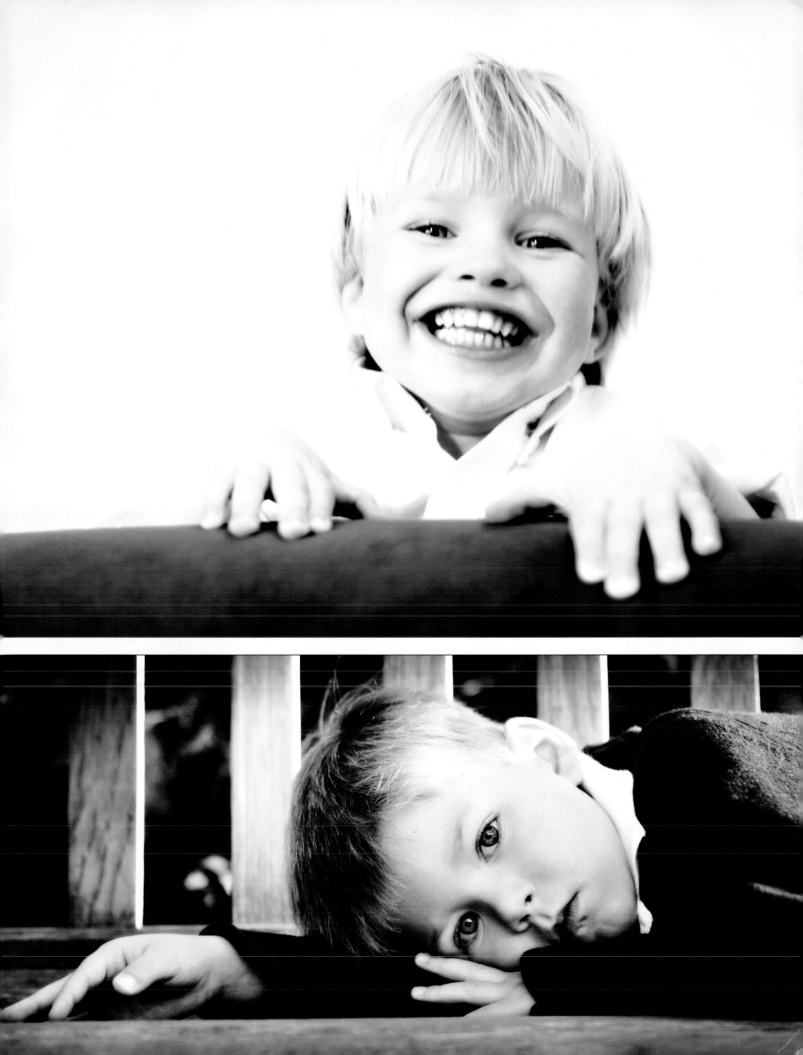

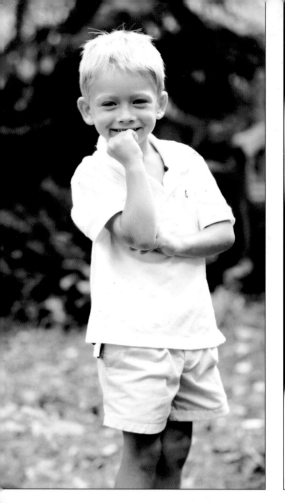

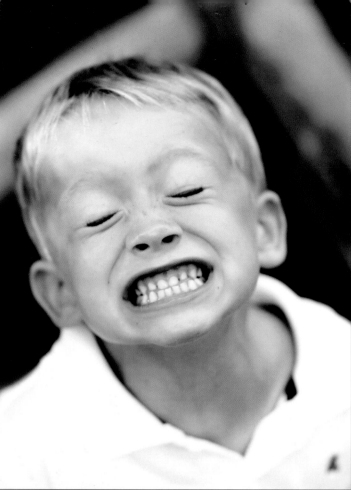

THIS PAGE AND FACING PAGE—The beautiful, more sensitive child.

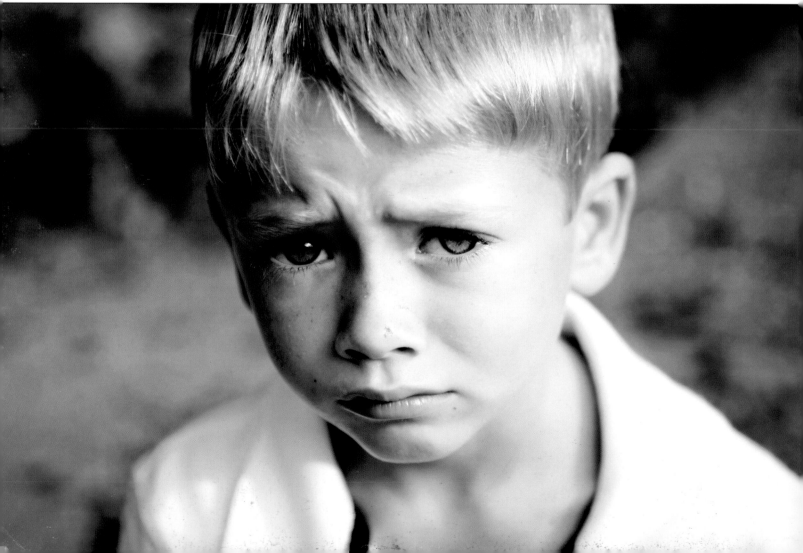

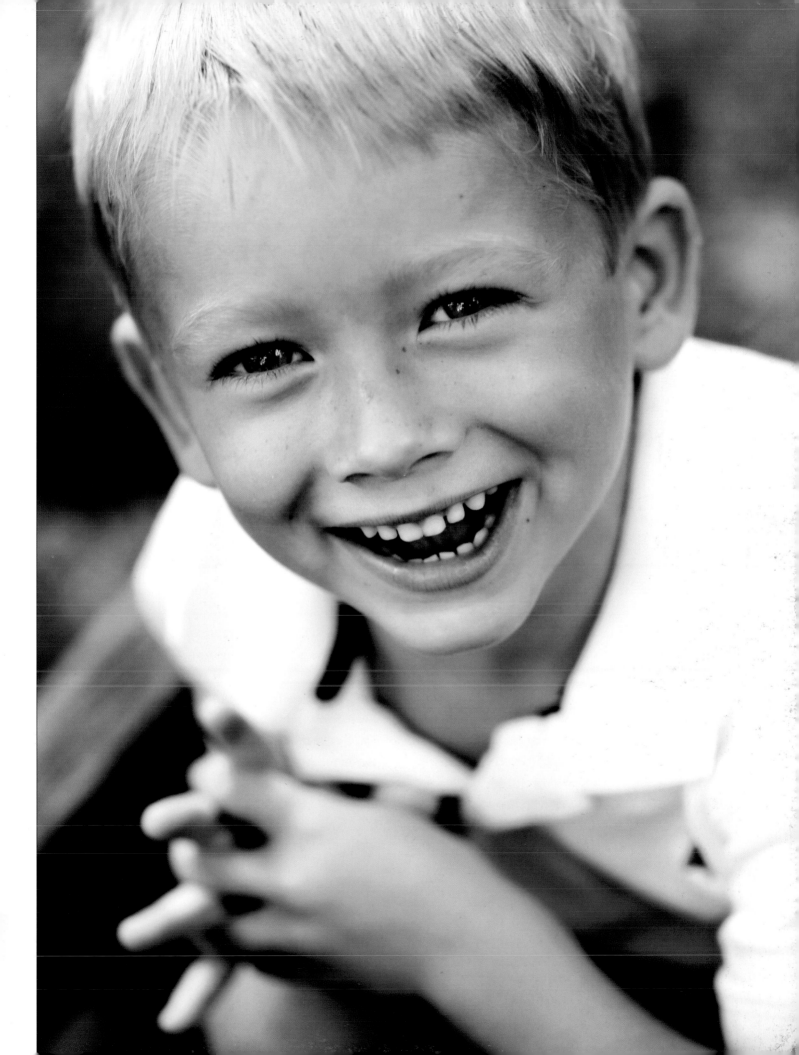

However, you should be on your guard to not collect too many similar looks in a row, as there is so much give and take during these sessions. This is a great occasion to utilize surprise tactics or interesting diversions, which will allow you to capture a richer spectrum of expressions and smiles. Interactive children are usually very amenable to trying new things, like racing around that tree as fast as they can in an effort to beat the world record currently held by the Owl-Spotted Blue Squirrel from the southwest province of Saskatchewan (who knew?!). Or to see if they can count to twenty in Spanish—without messing up once—while you capture that focused expression as they see every number in their head and pause for a just a moment to remember the correct pronunciation of *catorce*.

The One Who Just Needs To Warm Up. The one who just needs to warm up can be an excellent, easy subject to photograph. You only need to remember to give them time to get used to you. Once they finally let you see them in their natural state, you can capture a solid range of expressions and also be invited to tacitly observe their interactions with others. But be aware of the length of the warmup phase. If you jump in too quickly, you can throw a child off track—and that can end up alienating them.

I felt I'd pretty much mastered the ability to "get" kids, when I met five-year-old Emily and three-year-old Andy for the first time. I received a couple shy smiles in response to my hellos and started talking to them a bit, getting them used to the camera and my shooting style. After a while, I laughingly told Emily

that her eyes looked like a cat's (they did!) and I wanted to hear her meow. I then growled softly and swiped at her with my "claw." *Every* time I've done this with a young girl in the past, she's laughed (if only out of embarrassment for me, perhaps). I still think that if I had whipped out my claws a mere five minutes later, Emily would have laughed, too. Unfortunately, I underestimated her warmup time. Emily's eyes instantly filled with tears and grew wide with panic. She yelped while jumping behind her mother—desperately trying to get away from this psycho lioness photographer freak who was actually *growling* at her. A complete misfire. I was sure to handle her much more gently throughout the rest of the shoot, and I tucked that experience away as an excellent lesson learned: Let them warm up all the way.

The "Spirited Child." There is a wonderful book by Mary Sheedy Kurcinka entitled *Raising Your Spirited Child* (Harper Paperbacks, 2006). Her general concept is that there are a lot of children out there who are simply "more"—more intense, more sensitive, more perceptive, more persistent, and more energetic. Simply put, the theory is that for too long children have been labeled as "difficult" when they were just "different."

> *Dismissing their feelings as unreasonable isn't going to help you capture amazing images.*

For example, kids with this personality type can experience a significant state of frustration over an occurrence that might only mildly annoy another child. However, simply dismissing their feelings as unreasonable isn't going to help you capture amazing images of this child. You need a different approach when communicating with these kids—and, perhaps even more so, when receiving communications from them.

BELOW AND FACING PAGE—Watch your subjects. You never know when a child will do something delightfully unexpected.

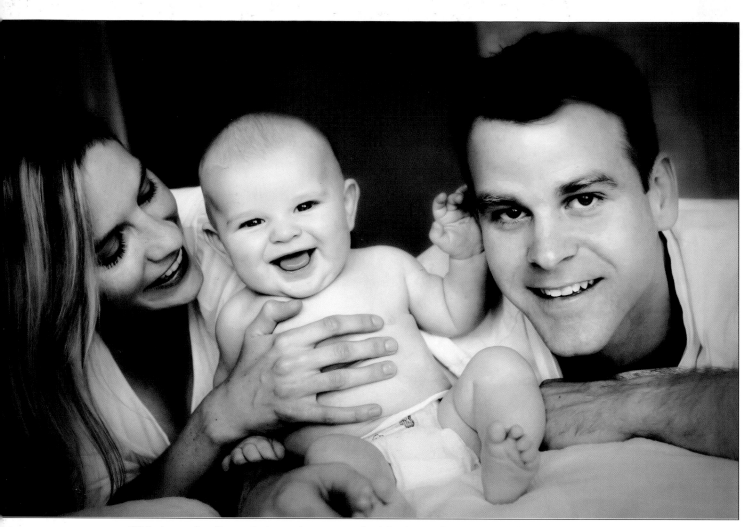

ABOVE—While it may be disappointing to have to reschedule due to illness, wonderful, natural emotions are easier to come by when the child is not sick for the shoot. **FACING PAGE**—Temporary bad moods and tantrums, on the other hand, can sometimes result in memorable portraits.

The spirited child may just need more of a truly attentive response from you—and there are some great reasons to provide that attentive response. First, these children are rarely dispassionate; you do get a lot of emotion, and that is a joy to photograph. (Just know that you need to pay a lot of attention to reading them properly so as to not put an early damper on the shoot.) Second, the most rewarding reason, you have a rare opportunity to show Mom and Dad that it is possible to get truly gorgeous photographs of their children. Parents with spirited children are typically even more impressed than the average client when viewing the insightful images you were able to get.

Often, many others before you will have failed to do so. As a result, they will truly appreciate the fact that you took the time and effort that was required.

The One Who is Sick, Tired, and/or in the Midst of a Four-Hour Tantrum. One of the best things you can do to ensure a consistently high level of quality in your work is to encourage a re-shoot when your client's child is sick or feeling under the weather. It's true that children are very resilient, but even the most upbeat and happy-go-lucky child in the world can get thrown for a loop when she is feeling miserable. Sometimes clients will try to "power through" an illness because, for whatever reason, they

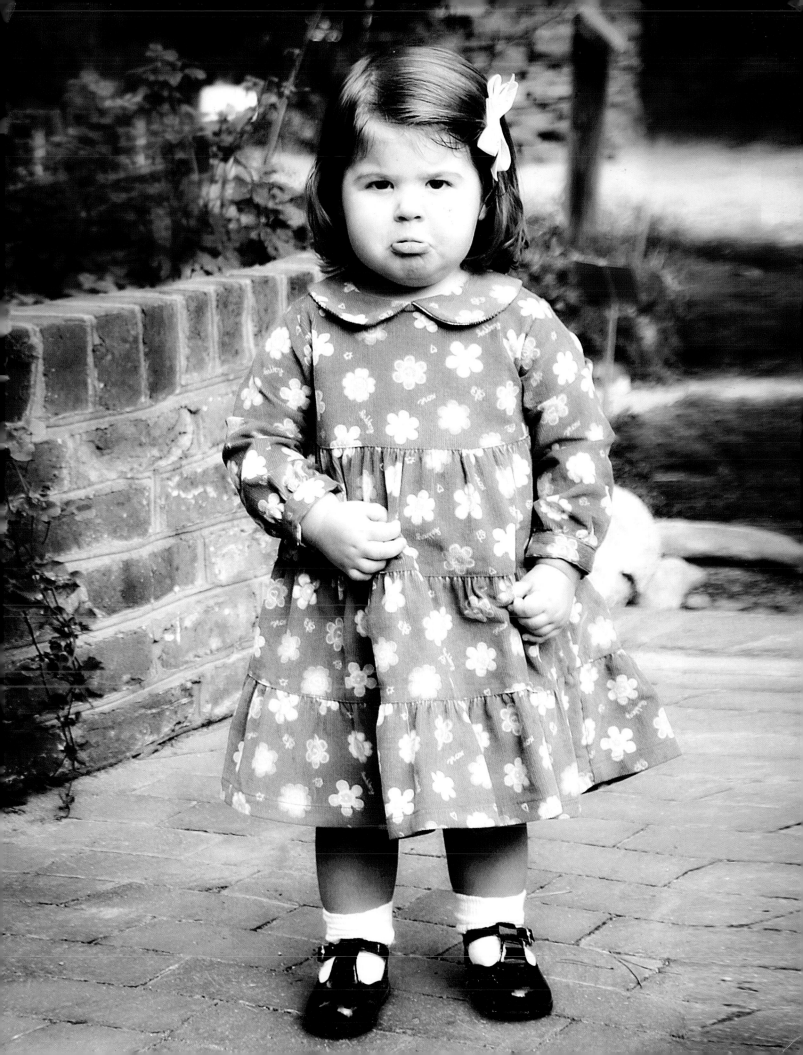

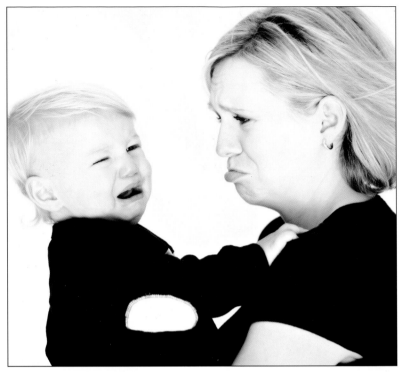

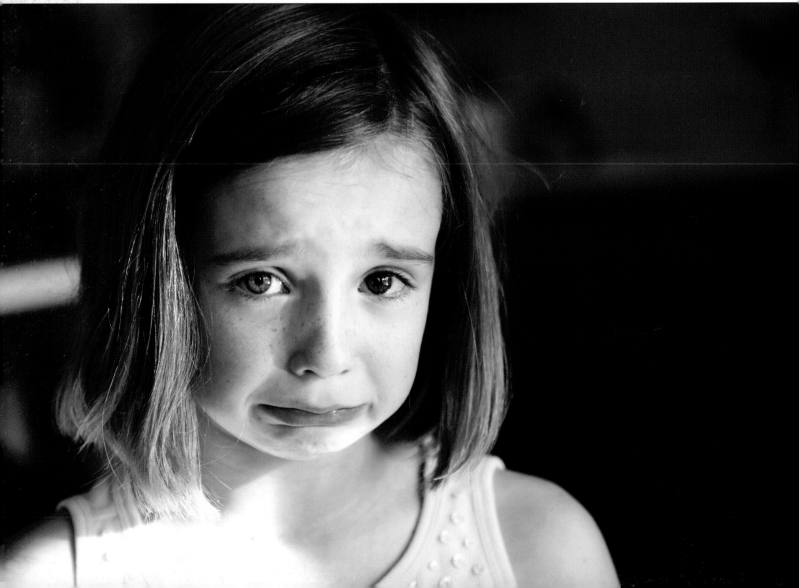

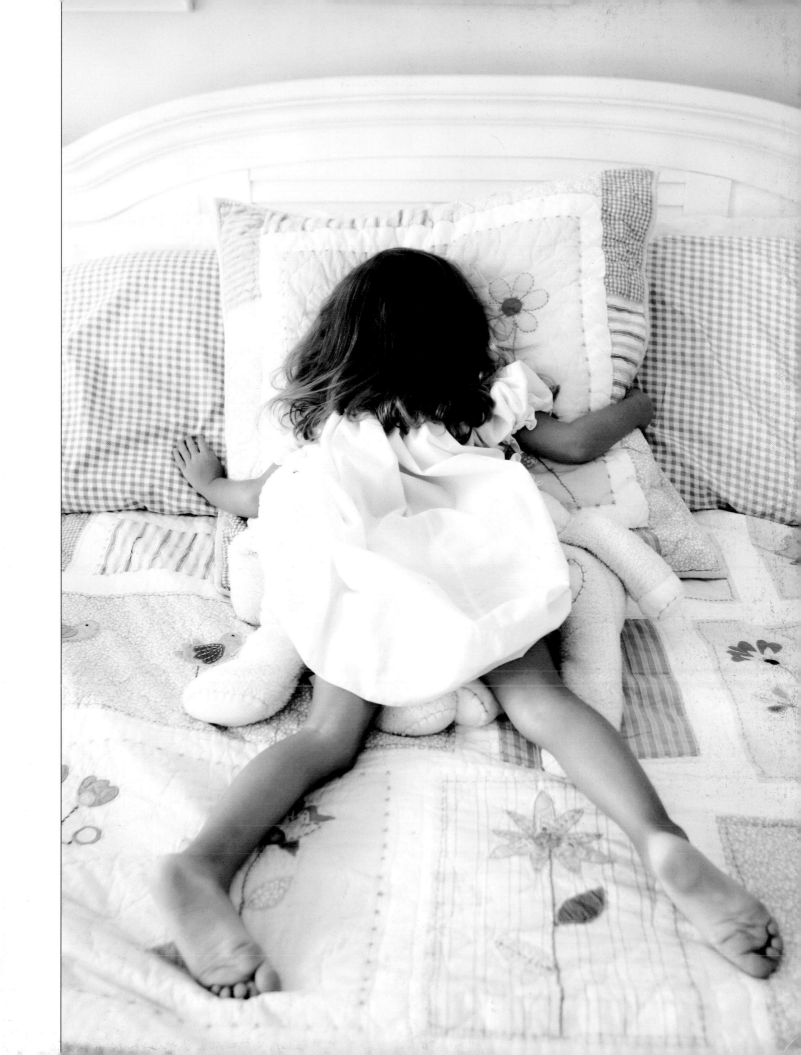

ABOVE AND FACING PAGE—Falling in love with your subjects can help you connect with them quickly and intuitively.

want the session to happen now. Make it easy on them and let them know you will reschedule a shoot at the earliest mutual convenience—but do your best to encourage a postponement of the session. The reason for this is threefold:

1. The kid is sick. Sick feels miserable. Let him take a break.
2. The kid is sick. Sick spreads—and when you get sick, you have to postpone other clients' sessions.

3. The kid is sick. Even if he somehow magically sucks it up long enough to get through a shoot, clients often look back at their proofs and think, "Oh, poor little guy, he was so sick when we took this photograph."

Even if your client doesn't feel like they want to postpone the day of the shoot, they may feel differently later—especially when they can see that special droop on their child's face (something that you may not even recognize) or the nearly uneditable watery eyes. Even if you manage to produce a magical, "perfect" shot—an image that would wow most anyone—you will still find yourself sitting there right next to the parents and listening to them say, "Oh, my poor little guy. I just know that, behind that smile, he was completely miserable." Those negative feelings just don't translate well into purchases.

A tantrum, on the other hand, is not so bad. If the child is just easily upset or feeling particularly moody that day, you can work with this emotion to produce some gorgeous imagery. Just remind your client that the actual crying sounds don't make it to the final image!

Why Falling in Love Easily is Good for This Career

Sure, it's a little cheesy, but falling in love easily can really help you to connect with your subjects quickly and genuinely, which typically leads to capturing the most honest photographs. If you can intuitively see the authentic beauty of your subject in a very short amount of time, you're halfway down the road to consistently producing incredible work—for them and, always, for yourself.

Let's look at a typical portrait session. If you are spending an hour and a half intensely focused on a child, it can be normal to feel a pang of regret when they leave, even while simultaneously wiping your brow in relief (after all, that kind of absorption can

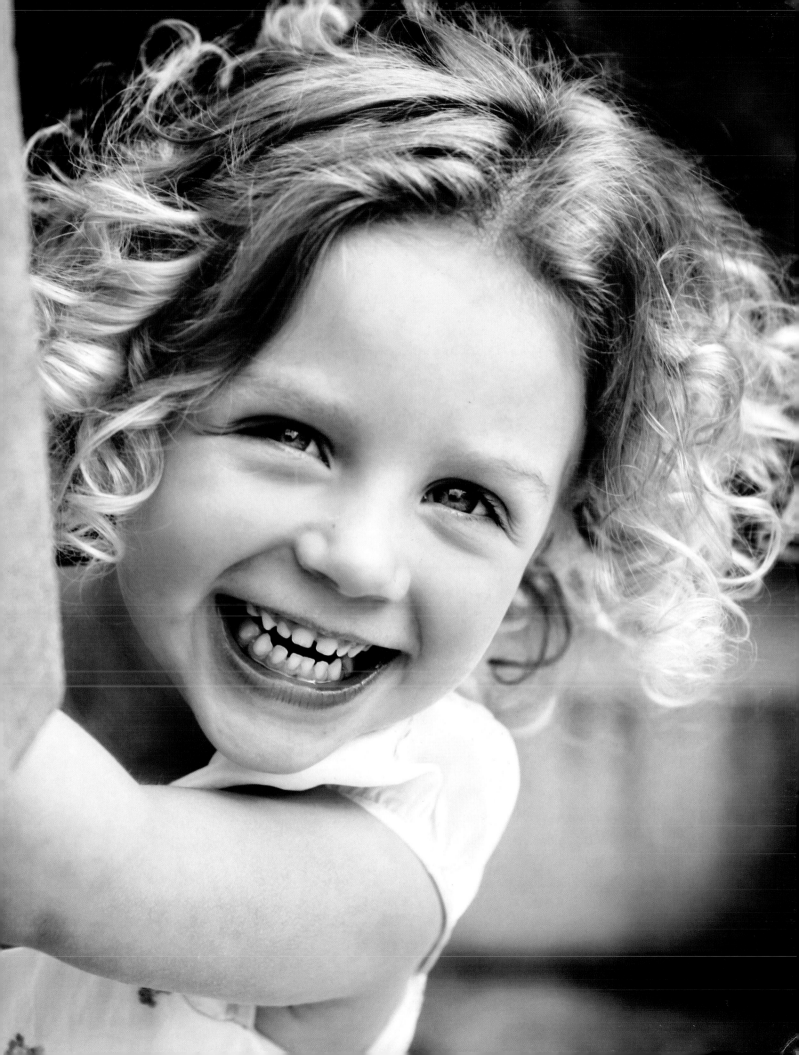

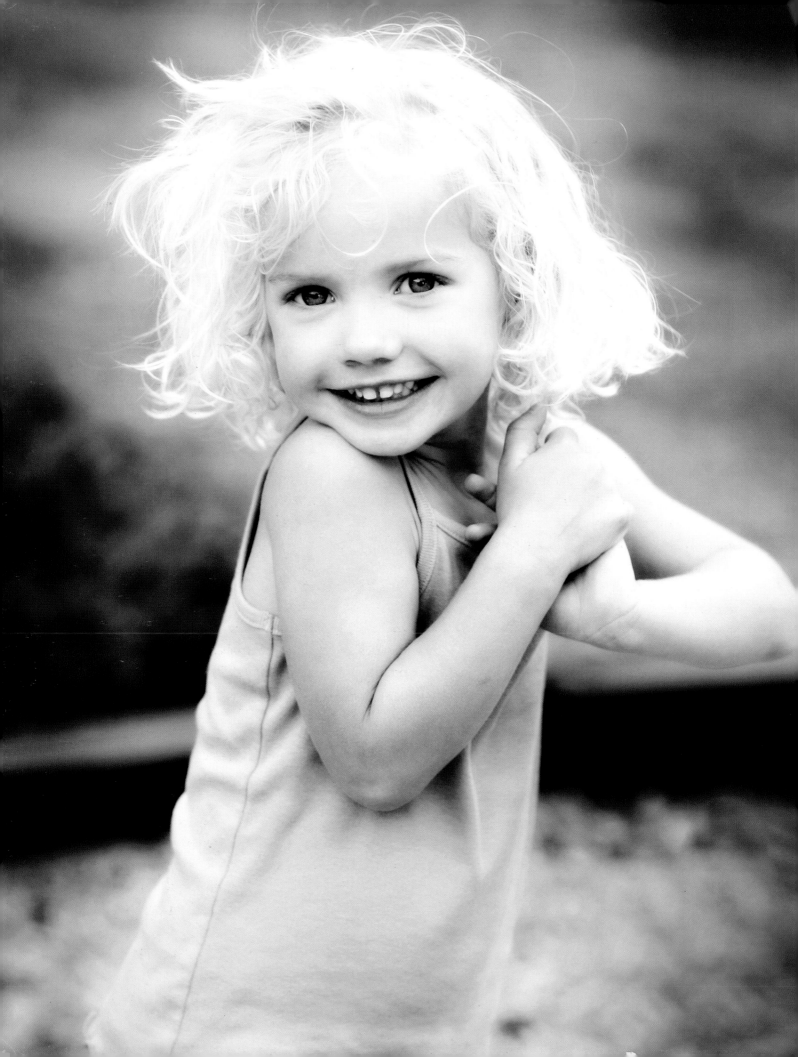

also be exhausting). If you can learn to really lean on these feelings, to tap in deeply into this emotional drawing-in to your subject, you will find it nearly effortless to provide the most authentic images possible for your client.

Think about the benefits of this attentiveness. When you are photographing the face of a child, you are looking at everything about them. You can't help but see what makes them lovely. And when Mom sees the face of that remarkable child of hers and how you captured the child's vibrant nature—well, you are showing her something that, pure and simple, represents *love*. That face means everything in the world to her. How can it not be beautiful?

Also, when you look at everything about a person, there are often times when you identify wonderful attributes in a subject that they cannot see in themselves—or attributes they have learned over time and through societal pressures to find unattractive about themselves. One great joy of this profession is the ability to bring back your subject's awareness of their own beauty. For example, a mother in her late thirties may lament the recent appearance of soft lines around her eyes. You, however, might see those same lines as evidence of much laughter and happiness. Seeing the allure of that, you can be sure to pay attention to capturing her joy. Hopefully she will see those soft lines in a new light, the way you do.

There's something pretty beautiful in those special attributes, and you get to showcase them.

A four-year-old boy offers a clenched smile whenever he sees you pick up the camera. His jaw line looks like it is clamped together in a nearly painful manner, and he jerks his head this way and that way as you move about. What you are seeing is a little boy who

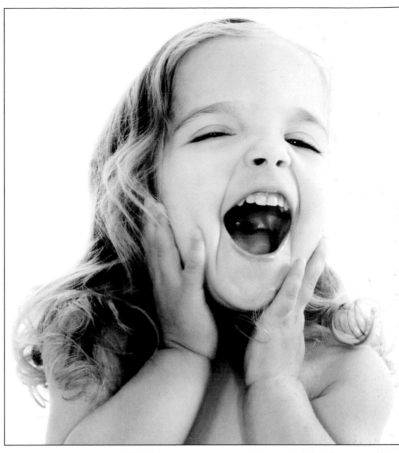

ABOVE AND FACING PAGE—Kids' faces mean everything to their parents. When you can really capture the child's personality, you're showing the parents something that represents love.

follows directions to a T (even now, just behind you, he's being told to keep smiling big). This is a child who wants to please you and Mom, a child who is nervous about getting it wrong. So you get to focus on that—on photographing a little guy who wants to please others, who cares a great deal about what they think of him. You look at his determination and how he puffs up when he gets something "right" and you get to the root of that. There's something pretty beautiful in those special attributes, and you get to showcase them.

A precocious but increasingly self-conscious eight-year-old announces that her brand-new teeth are too big in her head, and her little brother takes that particular opportunity to laughingly call her buck-toothed. If you can look at their exchange as him try-

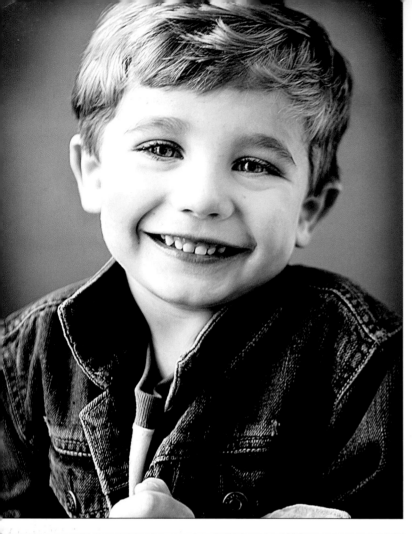

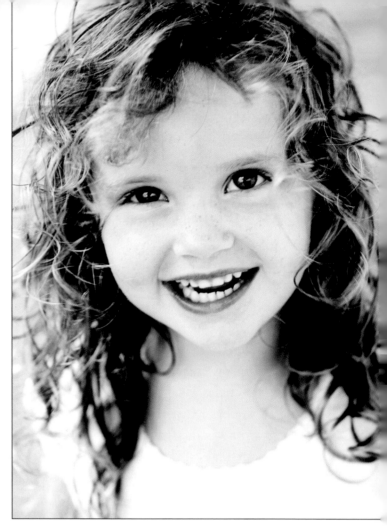

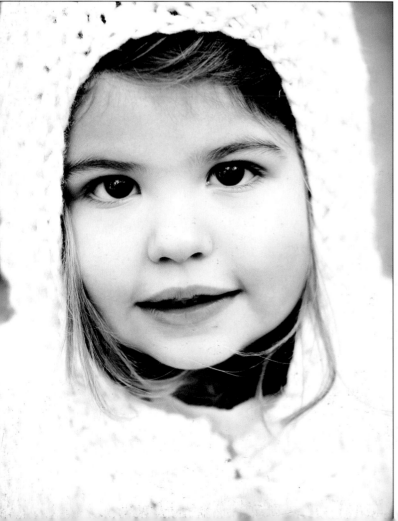

One absurd sentence can give rise of a variety of genuine expressions.

ing desperately to get her attention (and her simply not recognizing how beautifully she's growing into those lovely teeth), you can hone in on two major themes throughout the shoot. First, work on capturing his masked affection toward her; showcase it so it's obvious to anyone who looks at that image. Second, shoot her at her best, finding the most flattering angles to showcase just how adorable she really is (this may well be when she's unaware of the camera).

One of the most satisfying outcomes from a shoot is to see an insecure subject light up at how attractively they are seen by others.

If It Doesn't Come Naturally . . .

Some people just tap easily into the natural cadence of a child's emotions, drawing them out with ease and

stepping back ever so slightly when they need a breather. For these people, it can be an effortless exchange—as much a gift as the ability to photograph beautifully. For others, that may not be the case. Luckily, there are several things you can do to make it seem like it all comes naturally.

Draw Them In. Connecting with a child can be challenging when you are holding a large camera squarely in front of your face. One great way to get them to look past the camera is to start a sentence that is *very* interesting to them and draw out the ending so they are totally engaged and will pay attention until you get there—often forgetting or ignoring the quick shot you take in the meantime. For example, you might say, "Did you hear about the dog who talked to people? His very favorite thing to say was . . . [click!] . . ." Then, insert your own goofy ending—something silly, unexpected, or simply nonsensical. Depending on the child, the response is either a "that's so silly" face (which photographs beautifully), a spontaneous

laugh (also a gold mine), or a "thinking about what you said" look as they try to decide if it makes sense. Either way, you have some genuine responses to that one absurd sentence.

> *Connecting with a child can be challenging when you are holding a camera in front of your face.*

Stay Current with Kid Culture. Learn all the big popular-culture references that kids are interested in. Know the words to the *Dora The Explorer* theme song, memorize the common lullabies, keep up with the latest in the *High School Musical* movies, the *Harry Potter* books, and all the big cultural touchstones of today's children. Get to know the mascots of all the local schools, take note of the common threads you hear in Mommy-and-Me classes at Gymboree,

No babies were harmed in the making of this photograph, but it was quite a funny moment.

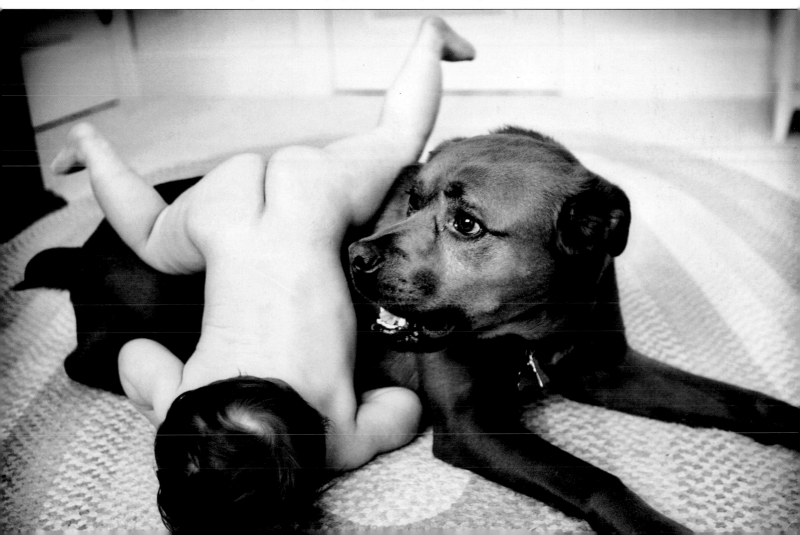

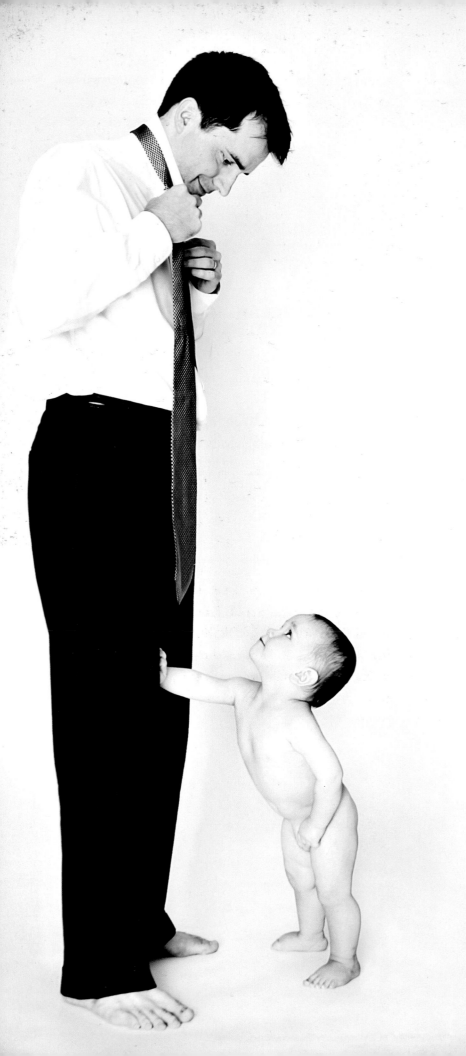

and learn which Disney princess is now the most en vogue. Watch an episode of Hannah Montana (or whatever the rage is among kids from year to year).

It helps if you have children; if you don't, tune in to some kids' channels or talk to parents and kids and find out what they are interested in today. It's like a secret language—and the language morphs quickly. A shared song can bring a child to life, whether it is "Twinkle Twinkle Little Star" or "You Are the Music in Me" by pop-culture icons Troy and Gabriella. If you know the dialect, you're a lot more likely to gain access to the culture.

Dress Casually. Dress comfortably, casually, and approachably. If you look too "buttoned up" you're an adult—you're "hands off." Strive for a clean, casual appearance: jeans, perhaps a shirt that showcases pop culture (or that you can at least roll around in), and sandals or nicer sneakers will do the trick. You will look clean and presentable, but you will still seem a great deal less intimidating to a child.

Be Patient! If "location, location, location" is everything for real estate, then for children's photography it's all about "patience, patience, patience" (well, maybe "patience, *lighting,* patience," but still . . .). It is important not to rush moments;

This spontaneous moment was priceless. Daddy had to get back to the office, but his son wasn't quite ready to let him go.

The littlest girl's pose and expression make this shot memorable.

don't try to power through the beginnings of a meltdown. Getting the best result from a session sometimes means putting down the camera and just giving everyone some downtime. This gives credibility to whatever feelings a child may have that are leading them away from wanting to interact with you. When they come back, open up, and let you get some incredible images, it is exceptionally rewarding to have been so patient.

Watch Your Subject. A Lot. Even when you are doing a different task or performing an unrelated activity—whether it is chatting with the parents, changing a lens, or walking in the direction of a new location—keep your eye on the prize. You never know when a child will do something delightfully unexpected.

3. Basic Portrait Photography Overview

When submitting prints for competition, there is a general set of criteria that you should follow if you are expecting high marks. Your photographs must display a "high standard of professional skill, creativity, and technique." If you ever have the opportunity to sit in on a print competition critique, you should do so. These are incredible opportunities to sit back and listen to wonderful information just wash over you. Outside of actual print competitions, though, you should still strive to capture your images with that same high standard of professional skill. Learn what you need to know to consistently produce high-quality imagery so that you can do so seamlessly.

Equipment

A photographer's bag of gear typically grows slowly over time. Key elements to your bag will be replaced more frequently than you'd expect. In this day and age, with such rapidly developing technology, you are likely to replace your camera more frequently than your lenses, so invest with this in mind. Most photographers will tell up-and-comers that the smartest thing they can do is buy the best quality lenses they can rather than making do with inferior equipment for longer than necessary.

There are many reasons why good equipment is important, but primarily it is because your images will look that much better out of the gate. When you are working with higher quality equipment, you are better able to expose your subject properly, you will capture significantly less digital noise, and you will be able to freeze your center of interest with greater accuracy.

These are incredible opportunities to sit back and listen to wonderful information just wash over you.

You can achieve three huge milestones with this basic improvement. First, you will capture cleaner imagery. This saves you significant time in post-production, which allows you to allot more time to practicing solid business-process standardization and to engage in forward-looking marketing efforts. Second, you will more quickly become known for the high quality of your work. Third, you will more rapidly build confidence in yourself, your work, and your business. Having and showing confidence is nearly as critical to your success as a photographer as knowing how to shoot beautifully. Do not underestimate the importance of this.

Once you invest in a great camera, read the manual. Seriously. Read it from start to finish. Prop your

eyelids up with toothpicks if you have to, but get through all of it. There's no better way to achieve a comprehensive understanding of the basic capabilities you have with that particular piece of equipment. Once you've learned every custom function on your camera body, your power to excel is nearly limitless—but you have to start with that basic resource. Even if you've been shooting for twenty years, you should start from the manual every time you purchase a new camera. You must know your equipment through and through.

What equipment you should possess will vary based on what you shoot and your particular preferences in terms of shooting style. At the very least, though, you should have the following equipment:

1. Two camera bodies (one main and at least one backup).
2. Several lenses. (How many depends on you, but most photographers have between two and ten. At the very least, consider one wide angle, one telephoto lens, and one favorite prime. Some photographers swear by zooms, others would never give up working solely with their primes; many are in the middle.)
3. On-camera flash.
4. Backup on-camera flash.
5. Flash cards or film, in protective cases.
6. Lens and body cleaning kit. (This should include, of course, a lens cloth or two.)
7. Batteries and backup batteries. (For both your cameras and flashes.)

In addition, there are some accessories you may want to consider, depending on your style of shooting:

8. Tripod.
9. Lens filters.
10. Battery power pack with necessary connectors.

11. Spare LCD covers, lens caps, eye-cups, etc.
12. Portable studio lights with remote radio trigger and receiver.
13. Collapsible reflector(s).
14. Video light(s).
15. Dust blower.
16. Rain gear.
17. Battery charger(s).

Obviously you can continue to add to your bag as desired, but keep in mind that you lose some agility by carrying too much "stuff."

What equipment you need to carry for a location shoot will depend on your portrait-shooting style.

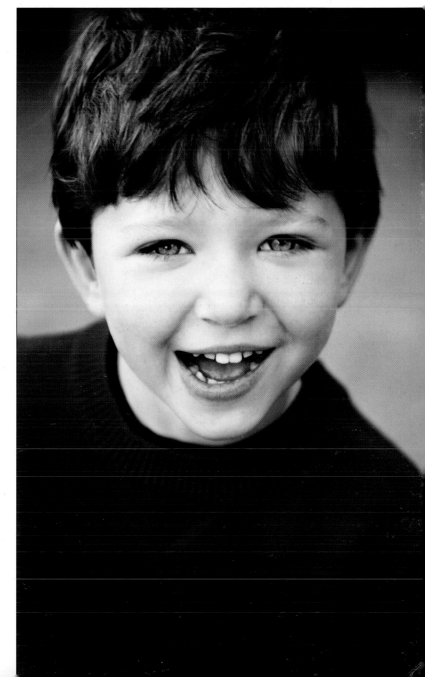

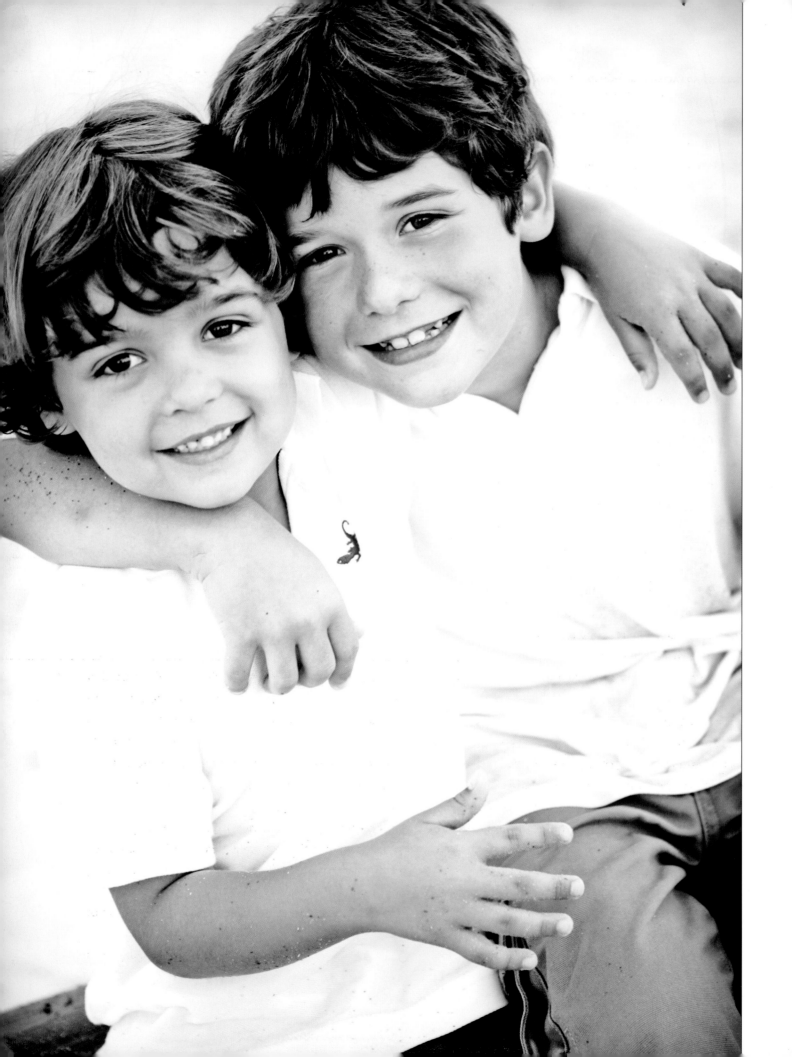

Lighting

Lighting is, well, *everything* when it comes to portrait photography—or really any type of photography. There are volumes of text dedicated to studio lighting, and there are a number of them that are quite worth the read. Once you start mastering your in-studio lighting setup, you'll find a whole new world opening up to you in terms of matching the creative vision in your head.

One of the most important aspects of contemporary photography is finding fresh looks and feels. Therefore, keeping the same exact lighting setup for every image is going to certainly get stale after—hopefully—only a short while.

It's up for debate as to whether on-location lighting is "easier" to manage than studio lighting. If you do not have access to a studio, we definitely have a clear winner; it is *way* easier to shoot on location. But if you do have a studio, and your lighting abilities are rock solid, then you will probably find more of a challenge in location lighting.

Location Lighting. The primary consideration with on-location shooting is usually the overhead direction of the lighting through much of the day. As a result, deciding on the time and place for the shoot usually has a lot to do with where the sun is and what opportunities you may have for natural shading during those times. On a sunny day, a beautiful, simple time to shoot is around sunset (just before, during, and after). When you have lost the squint in your sub-

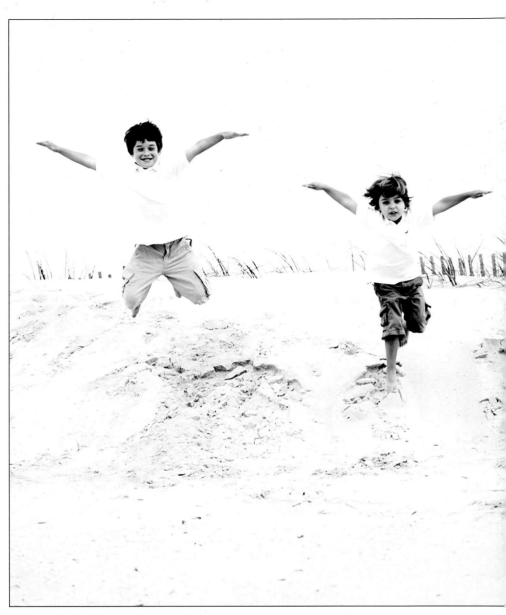

ject's eyes and the lighting is changing from golden to orange to purple, you have great freedom to position and/or track your clients as you wish. As long as you are watching where the shadows drop (especially *your* shadow as you stand between the setting sun and your client), you can have a lot of fun with this sweet light.

Of course, there is a caveat: this perfect light usually occurs at a time of day when your little subjects' body clocks are not doing their best ticking. Children, and especially babies, are usually at their best in the morning. Fortunately, that is the second best time of

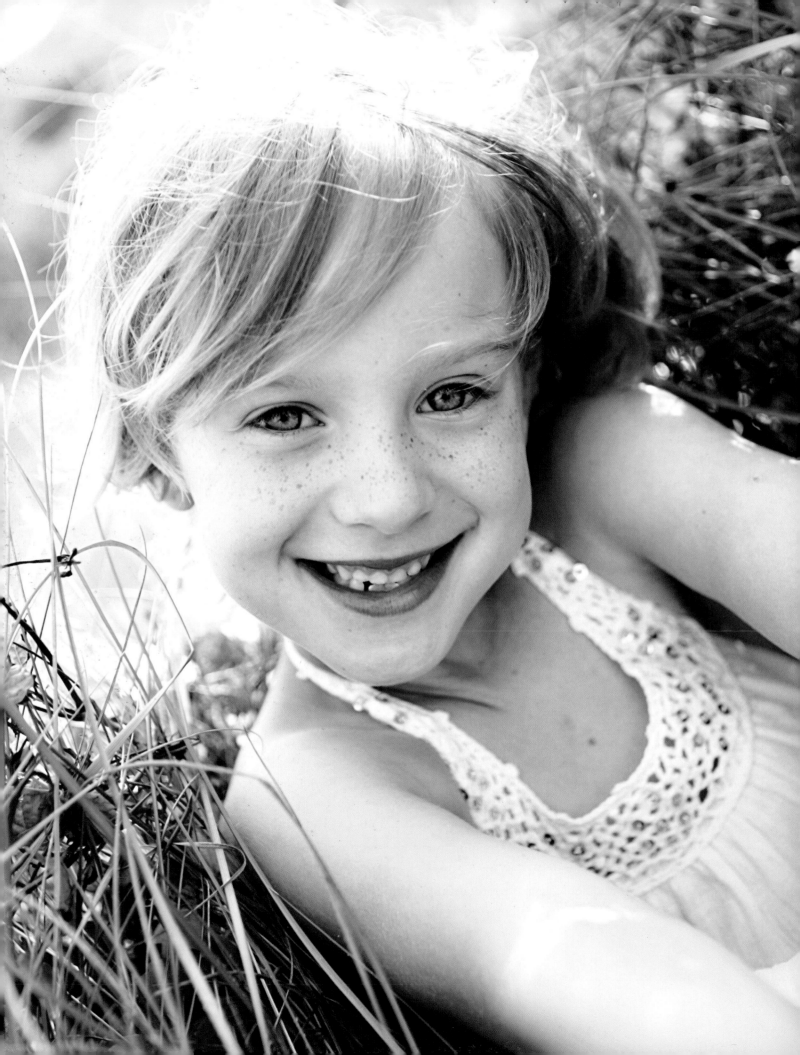

FACING PAGE AND TOP RIGHT—Rim lighting can create a great look in your portraits. **BOTTOM RIGHT**—Don't underestimate the joyful look you can capture by merging emotion with blinding sunlight spilling all about. This image would not have been nearly as striking or emotive if it had been "properly" exposed.

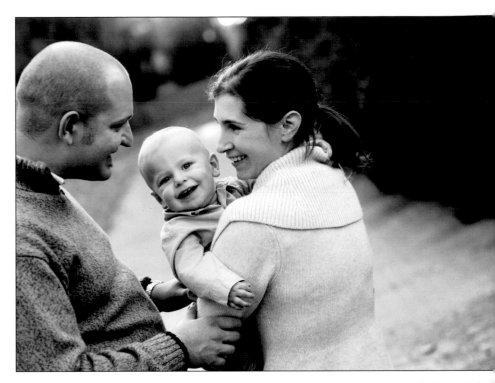

day to shoot on location. Early in the morning you can easily control the shadows on your subjects' faces and reduce problems with squinting. The exact time of day changes with the time of year, daylight savings time, and how early your client feels they can get their kids assembled, cleaned, and out the door. A good rule of thumb is to start at about 8AM.

The exception is when you are shooting beach sessions. In that case, you probably wouldn't want to start later than 7:30AM. This is because, first, there is a general lack of natural shading in the beach environment. Second, as the sun rises, there will be more reflections off the sand and water. This means more opportunities for children to squint. Finally, at beach sessions you usually are battling the heat of the summer, a very popular time of year to photograph beach portraits. For this reason alone, the earlier you start, the better.

You should also consider shooting against that early morning light (with the sun striking the subject from behind); when the light scatters a bit more, you

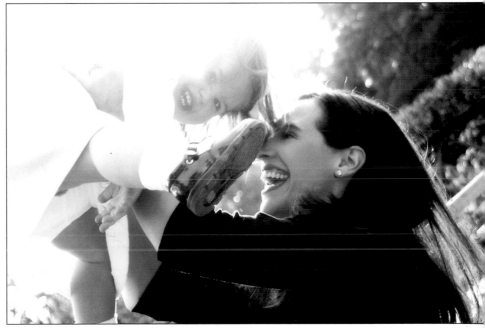

can achieve some very beautiful, sun-drenched looks. By varying your camera position—taking some images with the sun behind you, some with it in front of you—you can increase the variety of your imagery.

You can use sunlight as an excellent rim light, but be sure to position your subject in enough natural covering to deflect shadows from harshly contrasting against the face(s). Leave enough of them "exposed" to capture that beautiful bounce of light against the hair and to bring in a glorious golden light to the overall capture.

When the light has become too bright, you can still use natural shading (trees, overhangs, structures, etc.) to achieve good lighting outdoors.

The original image (left) was shot into a V-shaped foam-core board. With a little editing—some cloning and/or patching—the hard lines were cleaned up to create a more seamless backdrop (right).

Studio Lighting. When you are shooting in the studio, you have an incredible amount of options from which to choose when creating "the perfect light" for your session. You are basically considering three or four main factors: the main light, the fill light, and a reflector (for extra fill). Often, you should consider adding a back light or hair light, as well.

The main light is aimed at the subject to create the basic pattern of light and shadow on their face. One of the simplest ways to manage your main light is to use a large softbox and position it at a distance from the subject. This allows you soft, even lighting and a great spread of lighting to help track the little one as he makes his way around the shooting space.

The fill light is used to open up shadows that may be created on your subject's face by the main light (or any other ambient lighting). This can be an actual second light source (set to produce less light than the

main) or a reflector placed on opposite side of the subject from the main light. When using a fill light source, a supplementary reflector can also be added for additional fill. This is often used to create a more flattering and evenly distributed lighting effect across your subject, or to pop up catchlights in the eyes.

It's a good idea to keep a reflector in easy reach or attached to a small boom for easy placement when needed. Foam-core art board can be used as a simple and inexpensive reflector. This can be purchased in a variety of sizes (or cut down to whatever size you like), making it a very flexible option. It can also be very handy to create a large foam-core modifier by taping two pieces of 4x8-foot board together at one edge. This produces a large V-shaped modifier (often called a bookend) that can stand up on its own, making it great for bouncing light evenly across your subject. It can also be used as a simple backdrop when your subject scampers into it.

The following are some simple portrait lighting configurations to consider for a shooting room that has one main window.

The choice between an artificial lighting setup and natural lighting setup can make the same scene look very different. You decide. Do you want the look of man-made lighting for a crisp and clear shot—an image that really pops (left)? Or do you want natural lighting, for a warm, soft, and more gentle image (right)?

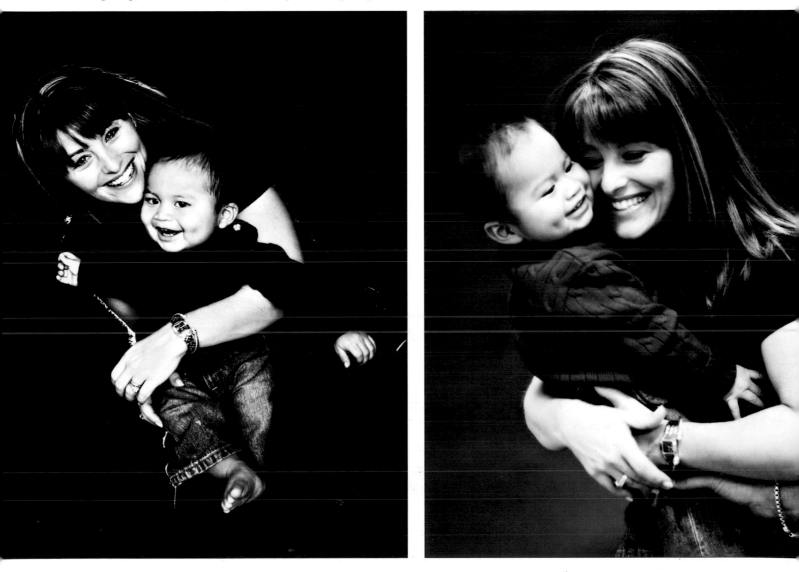

Setup A. This setup employs a main light (a large softbox), fill from a 4x8-foot bookend, a reflector, and a back light (see diagram). It offers you a clear, well-exposed image with flattering, even light. You may accumulate some shadowing, but it is usually to pleasing effect. This is a great setup for children who move around a lot! (*Note:* For this setup, the window is blacked out, so it does not affect the lighting.)

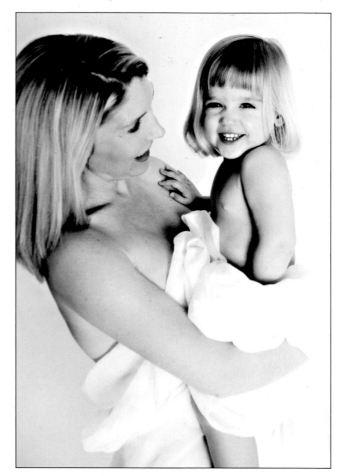

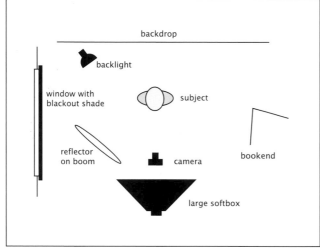

ABOVE—Setup A. **RIGHT, BELOW, AND FACING PAGE**—Images shot with the lighting shown in the diagram for setup A.

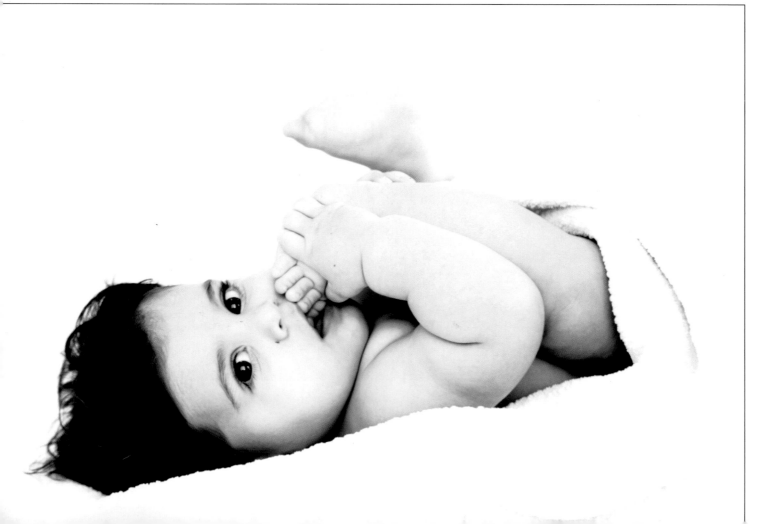

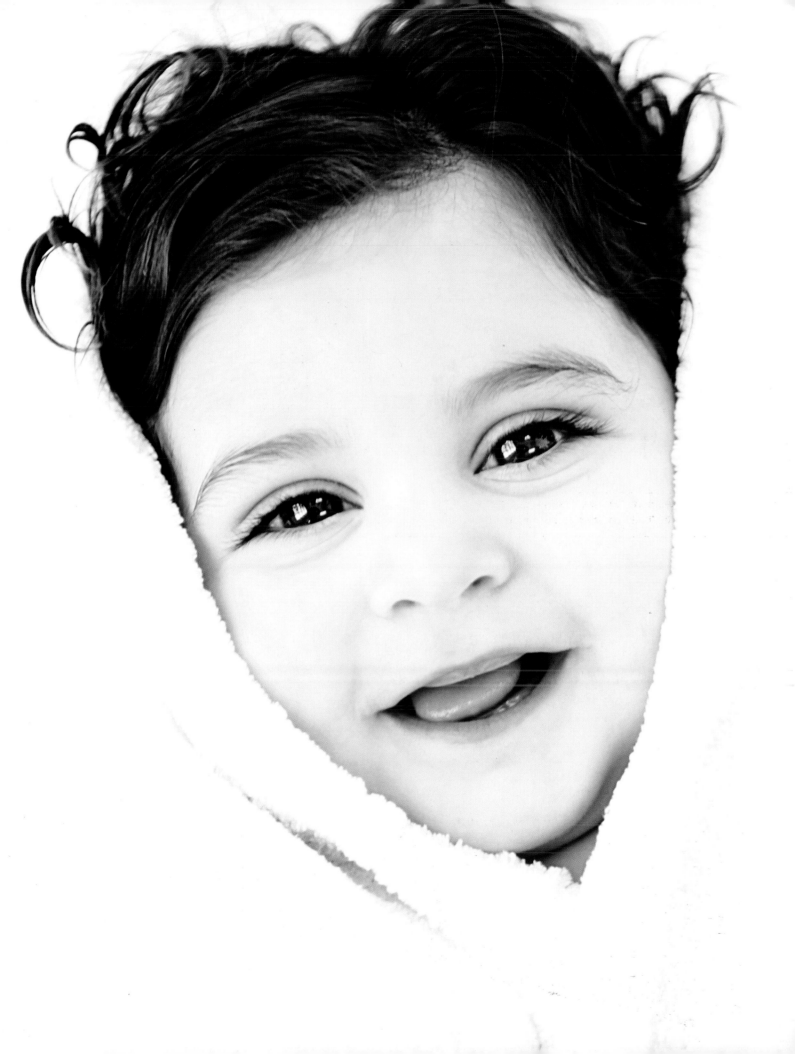

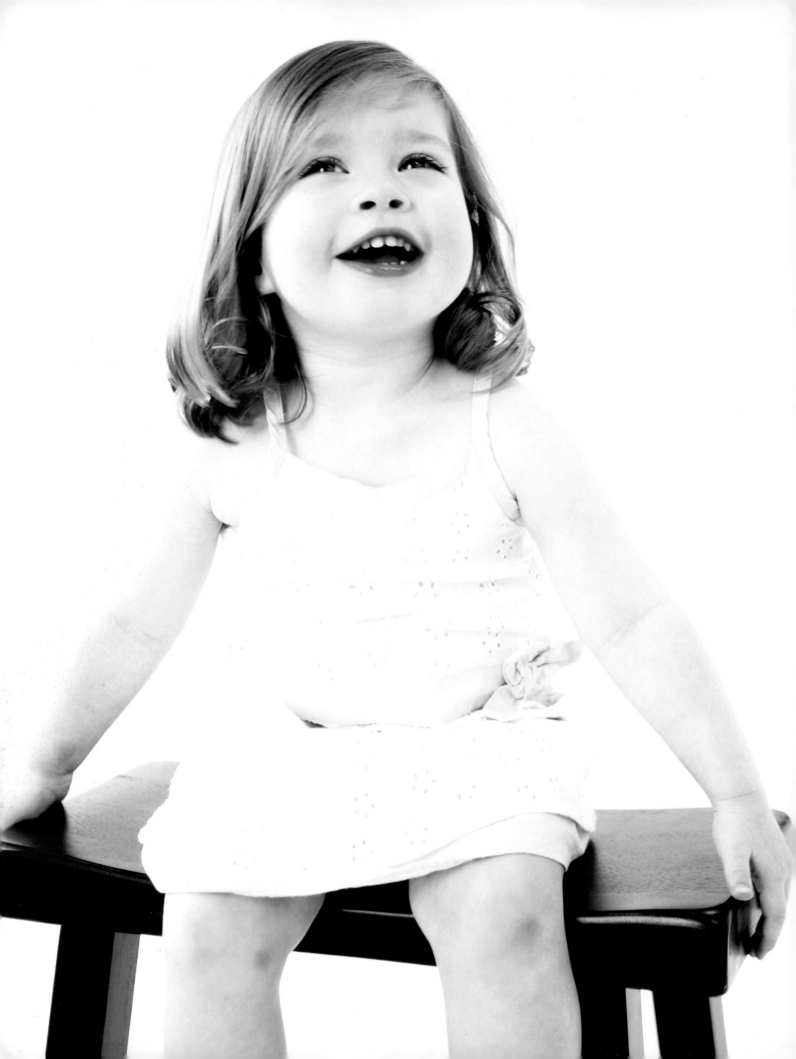

Setup B. This setup incorporates window light softened with a scrim as the main light, fill from a 4x8-foot bookend, and a reflector. Optionally, a video light can also be added. The light produced by this setup may be a little softer and warmer than that achieved with setup A. Because you do not have to wait for the lights to recharge, it also makes it easier to shoot in a rapid-fire style, so you don't miss that quick change in expression.

RIGHT—Setup B. **BELOW AND FACING PAGE**—Images shot with the lighting shown in the diagram for setup B.

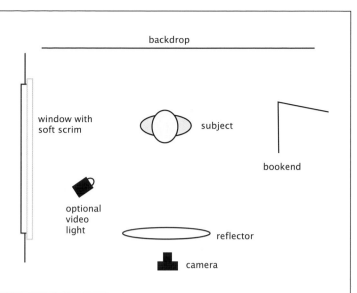

backdrop

window with
soft scrim

subject

bookend

optional
video
light

reflector

camera

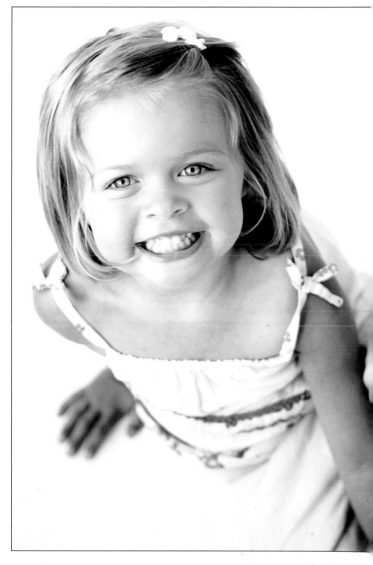

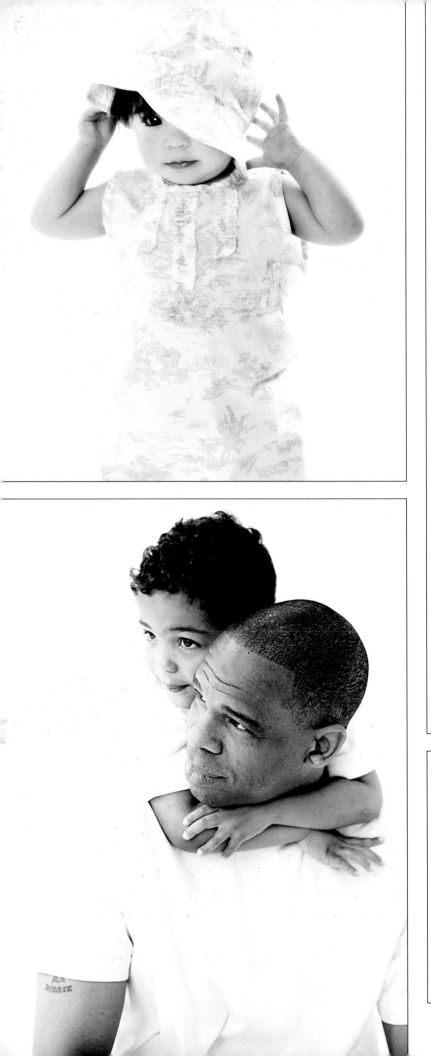

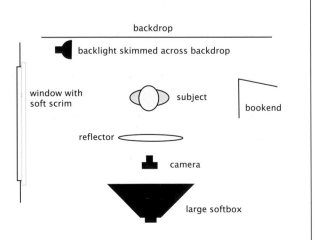

backdrop

backlight skimmed across backdrop

window with
soft scrim

subject

bookend

reflector

camera

large softbox

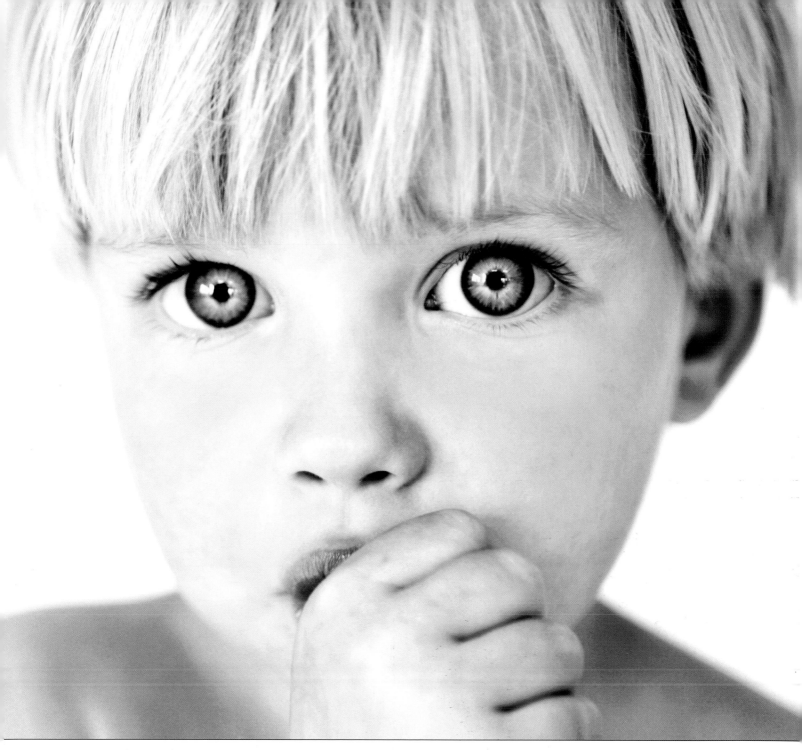

FACING PAGE, BOTTOM RIGHT—Setup C. **ABOVE AND FACING PAGE**—Images shot with the lighting shown in the diagram for setup C.

Setup C. In this setup, window light (with a scrim for softening) and a large softbox are combined as the main light for a controlled high-key look. Fill light comes from a 4x8-foot bookend placed to the side of the subject. Also used are a reflector and a back light. Altogether, this creates a very high-contrast, ultra-defining, minimally shadowed image that is bright and inviting. It does, however, limit you a bit in terms of how widely the subject can roam.

Adjusting the Backlight. You can play as much as you want with these suggested lighting setups. One of the easiest lights to adjust is the backlight, which you can move very quickly without interrupting the flow of the shoot. This will have a big impact on the

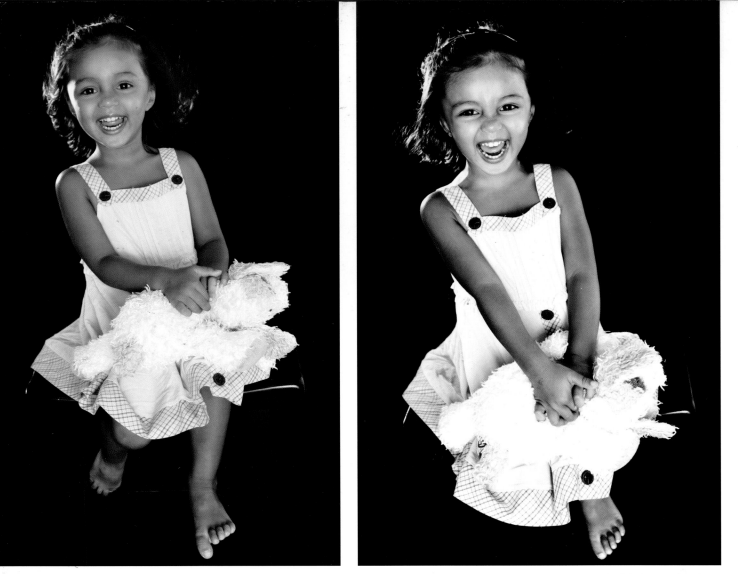

LEFT—A simple backlight was used to add a spark to the right side of the subject's face and accent the motion in her hair. **RIGHT**—The backlight was turned to bounce off a reflector in front of the subject, catching the highlights in her hair and further illuminating her face to provide more "pop" in the image. **FACING PAGE**—The backlight was dialed up for maximum "light spray," lending a more fashionable feel to the overall image. Note how shifting the light changes the tone of each of the images in this series, as well.

look of the image. You can create a great variety of looks by simply increasing the output of the backlight or bouncing it against a reflective surface to create more of a spray of side light. You can also adjust it to bounce against a reflector in front of your subject, highlighting more of the face.

There is no right or wrong way to light when you are playing with your setup. It's just about what you see in the subject and what you are most interested in showcasing to your client.

Night and Low-Light Shooting. You can have a great deal of fun working with low lighting. Depend-

ing on just how dark it is, you can opt for low-light equipment (shooting with an 85mm lens at f/1.2 and 1600 ISO, for instance) or add small continuous lighting options, like a video light. You can also consider bouncing on-camera flash when you are working in a more controlled environment.

When you want to shut off the flash (which is highly recommended!), look for ways to maximize your existing light sources. Consider screwing off the top of the lampshade for some targeted directional light—or just to add a more ambient feel. Of course you can always experiment with light-painting tech-

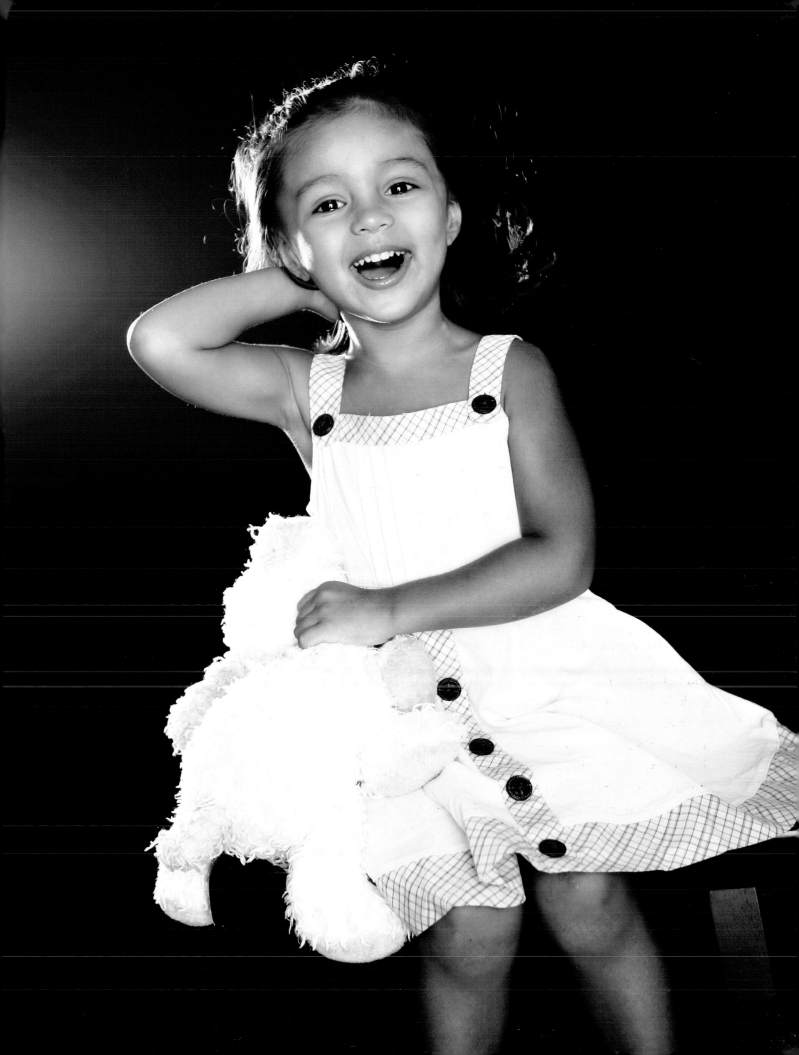

niques using flashlights, glow sticks, or other sources of light.

A great example of when you might want to consider low-light shooting is when you want to capture a child asleep and there is very little light in the room. This type of photography can add a wonderful element of ambience and really capture the feel of the room in the evening or early morning. You may want to use a tripod, if it is possible, or stabilize the camera by leaning against a structure. It is important to shoot with no movement.

You can also achieve striking looks with low-light photography outdoors, especially when it's actually getting a bit dark. (*Note:* When photographing children, this generally works best in winter, when darkness arrives a little earlier and your models aren't quite so exhausted yet.) You can achieve quite a moody feel by withholding the flash, shooting from a distance, and using a wide aperture.

There are nearly limitless opportunities for what you can do with low lighting. Consider using video lights in the pitch dark, or placing subjects near the soft, ambient light of candles. Try headlights, porch lights, and lampposts. When you feel comfortable using only

the glow of bright moonlight, you will realize that the sky is literally the limit!

Composition

Composition styles can vary widely, but there are some basic things to consider. What, exactly, is your center of interest? From what viewpoint can you best capture this center of interest? What will lead viewers' eyes to your center of interest . . . and where will their eyes go from there? These are all things you must consider when composing an image. An average image can become a thought-provoking photograph simply by the nature of how you compose it.

Camera Angle. When working with children, it often makes sense to shoot from their level. This makes for a lot of crouching down and seated poses for the photographer. Many times, a belly-down-to-the-ground camera position will deliver your best point of view.

Leading Lines. For an image to be viewed as pleasing and inviting, viewers generally want to be led toward the center of interest. Our eyes simply cannot take in every single part of the image at once, so there needs to be a path of observation.

The general school of thought is that we view images from left to right, just as we read words in Western languages. Knowing this, you can account for where viewers' eyes will go when they first see the image and compose it in a

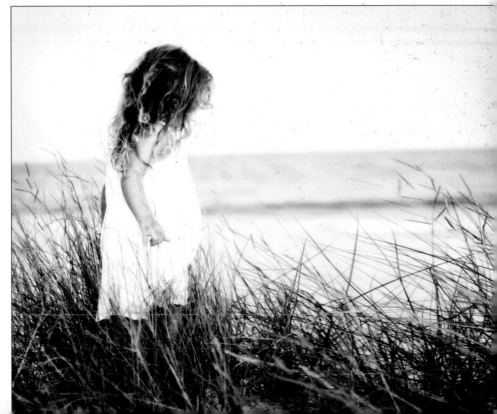

TOP—Notice how the armrest of this richly textured chair leads you up to the eye level of the subject. **BOTTOM**—The wind is pointing these reeds directly to the subject of interest.

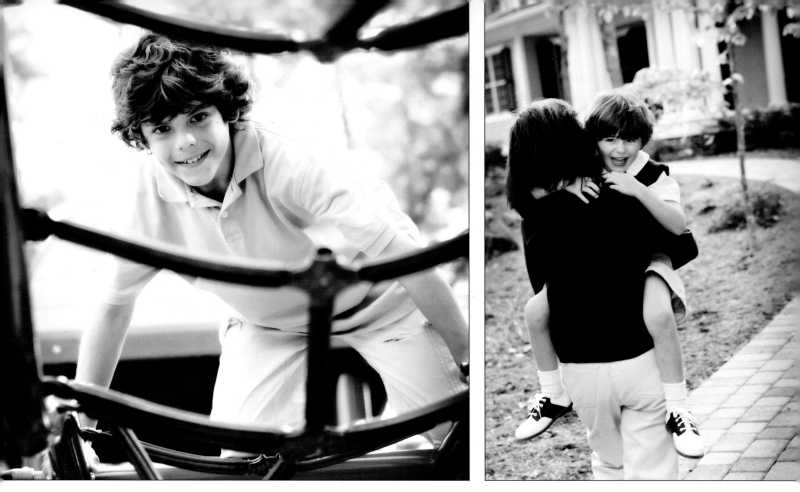

LEFT—Framing elements can help keep viewers' eyes on your subject. **RIGHT**—This circular path wraps around the two figures, leading the eye to their destination and then back to the subjects.

more compelling way. What do you want viewers to focus on most when they see your image? Where do you want them to "go" from there? And, if you are dealing with more than one subject, how are they relating to each other in terms of how viewers will "read" them?

> *What do you want viewers*
> *to focus on most*
> *when they see your image?*

One of the most effective ways you can direct viewers' eyes is through the use of leading lines. When our eyes encounter a line in an image, they tend to follow it. If you place your subject along or at the end of a leading line, viewers' eyes will follow the line di-

rectly to the subject. Leading lines can be large elements of the scene (walkways, boardwalks, posts, window panes, etc.) or more subtle linear forms (soft lines of flowers, the line where the water meets the shore, or even just a scuff in the sand).

Framing. Another pleasing compositional tool is the use of framing elements. These are lines, shapes, or other appealing visual elements that surround your center of interest (either partially or completely). These tend to lock viewers' eyes in place on your subject and often encourage viewers to see the little world your subject is in—right inside the image.

Subject Placement. Another important consideration is the placement of your subject(s) within the image frame. The subject can be either centered or off center.

The Rule of Thirds. One important "rule" for off-center subject placement is called the rule of thirds.

According to this compositional guideline you should imagine a tic-tac-toe board superimposed over your image. This divides the image, both vertically and horizontally, into equal thirds. To pleasingly compose your subject, you then place them at any one of the four intersections of these dividing lines (see sample below).

ABOVE—Placing the subject according to the rule of thirds results in a pleasing composition. BELOW—In some circumstances, centering your subject is the best way to compose an effective image.

Centering. While off-center compositions are usually recommended, sometimes shooting your subject dead center in the image can be a striking way to emphasize your center of interest—especially when viewers' eyes immediately meet the subject's front-and-center presence.

Creative Cropping. Shooting your work with an eye firmly trained to capture clever compositions will save you time, energy, and work in the long run. It's the cleanest way to shoot and often the most inspired. Still, there are definitely times when a moment occurs that you simply cannot miss—and you do not have time to lock in that killer composition.

When you are editing your images, look at what you are working with and think about whether there are things you can do to improve the composition. Could some changes be made to better represent your artistic vision of the scene, the subject, or the overall experience? Even if you initially thought you wanted a strong foreground, you might later realize that it detracts from the subject's delightful expression. To cor-

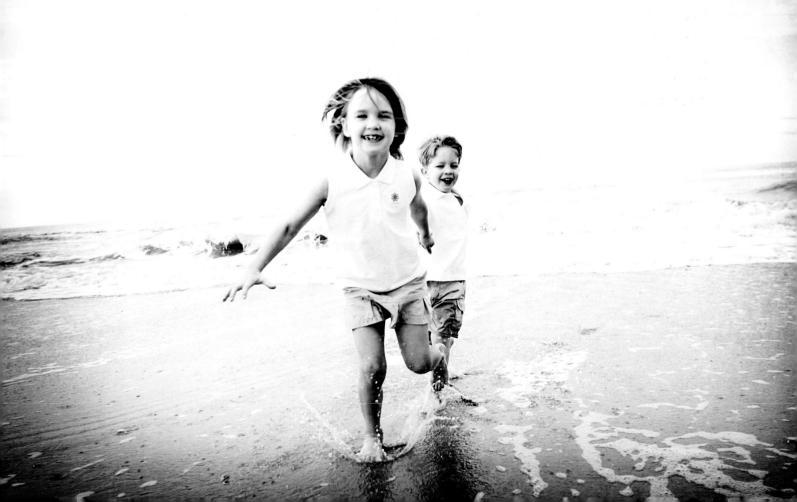

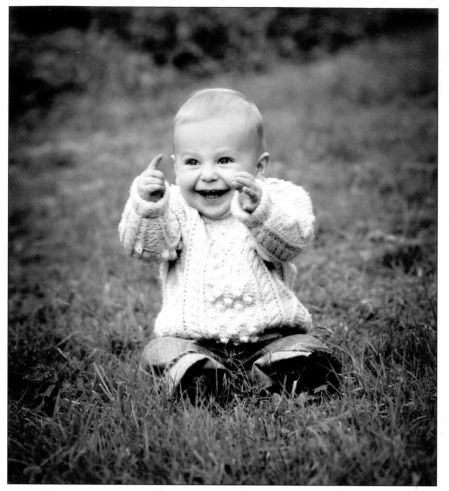

Here, cropping in tightly on the subject during post-production created a better image to present to the client.

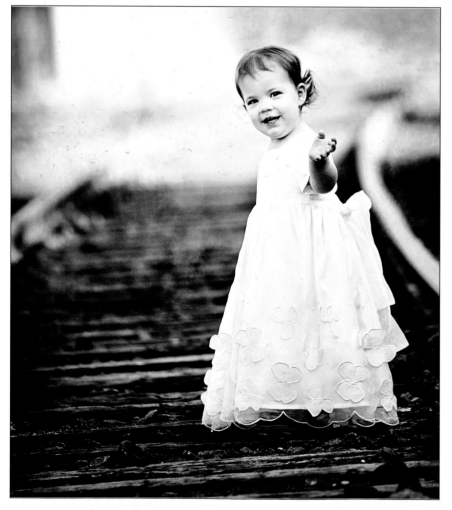

The initial capture (above) was good. In editing, though, the split in the two structures behind the subject began to seem distracting. Through cropping, editing, vignetting, and color toning, a much more striking image was produced (left).

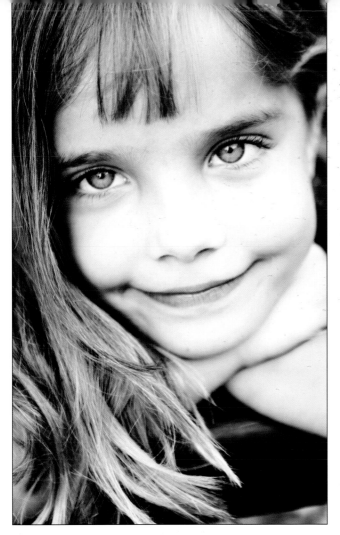

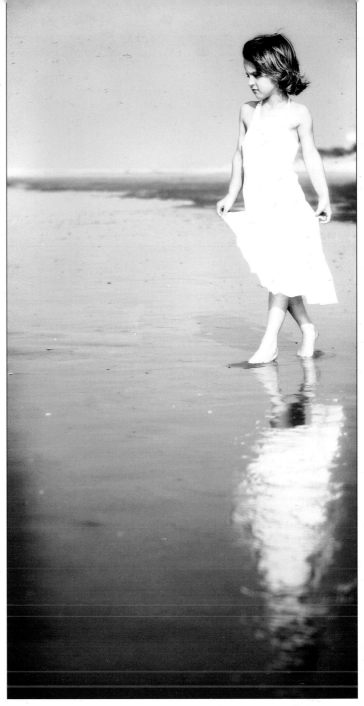

ABOVE—Tightly cropped images can be visually appealing and are quite popular nowadays. **RIGHT**—Consider using reflections to show two images in one frame.

rect the problem, you could crop the image to improve your print. Cropping can also help to reduce the visual impact of background distractions you may have overlooked (or not have had time to work around) during the shoot.

Cropping can also allow you to produce the extremely tight face shots that are currently popular. While photographers have largely been taught to not "chop off heads," this look is alive and thriving nowadays—and it can be quite arresting.

Posing

In contemporary photography, the word "posing" is sometimes used with a negative connotation. A lot of people say they want to avoid "posed" photographs when they really mean that they want more expressive imagery. However, posing is not a bad thing. Ideally, a lot of what posing is about is setting up an individual in a manner that is most flattering to them and photographing them from an angle and at a focal length that best showcases their attributes. Even if you never place a child in an exact pose and put her finger exactly like this and sweep her chin to the side exactly like that, it doesn't mean that you won't know a heck

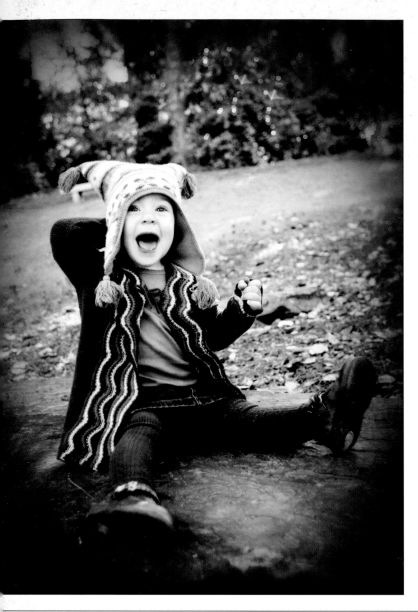

of a lot more about how to best flatter your subject by learning the basic rules of posing.

Some Simple Rules. The following are some simple rules to consider when looking for the best pose in a subject.

1. When posing multiple subjects, consider the physical distance between them. What may be a comfortable space between two subjects in everyday life may look pronounced in a photograph. Consider moving them closer together for an intimate and affectionate look.

2. Think about what looks comfortable and start there. Leaning against a wall, a tree, or a window; hugging knees to the chest; laying on their back with their head turned to the side; hands in pockets; arms crossed naturally; "self hugs;" laying belly-down with legs kicked up in the air—these are natural poses for children in their day-to-day life. Start with what looks normal and easy, then let it evolve from there.

3. When photographing a parent with their child, remind them to pay attention to posi-

THIS PAGE AND FACING PAGE—Start with poses that kids normally adopt in their everyday life, then go from there.

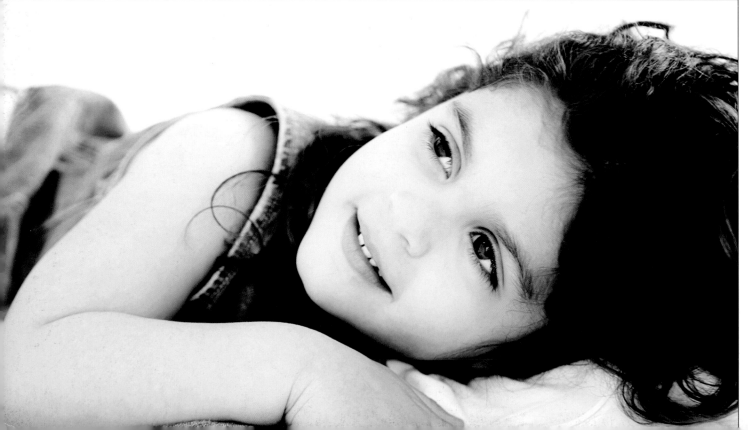

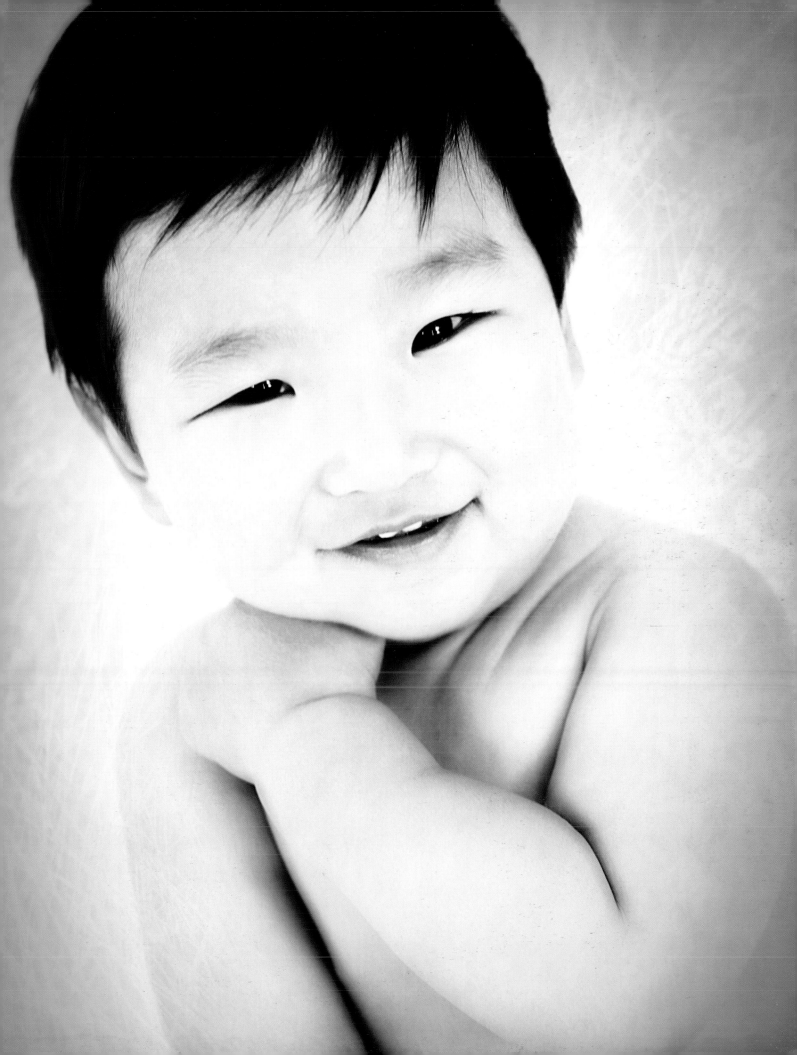

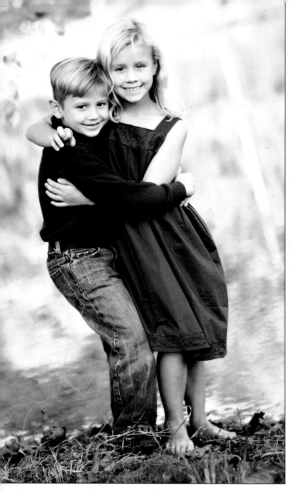

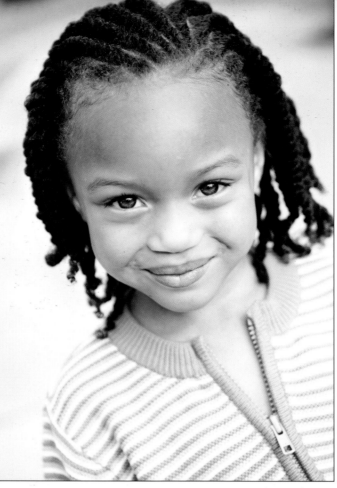

FAR LEFT—Look for ways to show curves, rather than straight lines, in your subjects' poses.

LEFT AND BELOW—A high camera angle can be used to accentuate a subject's striking eyes.

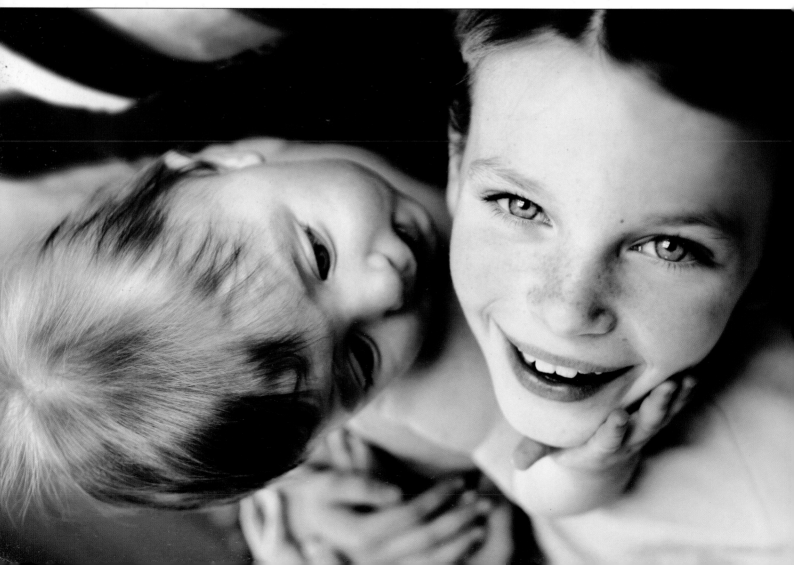

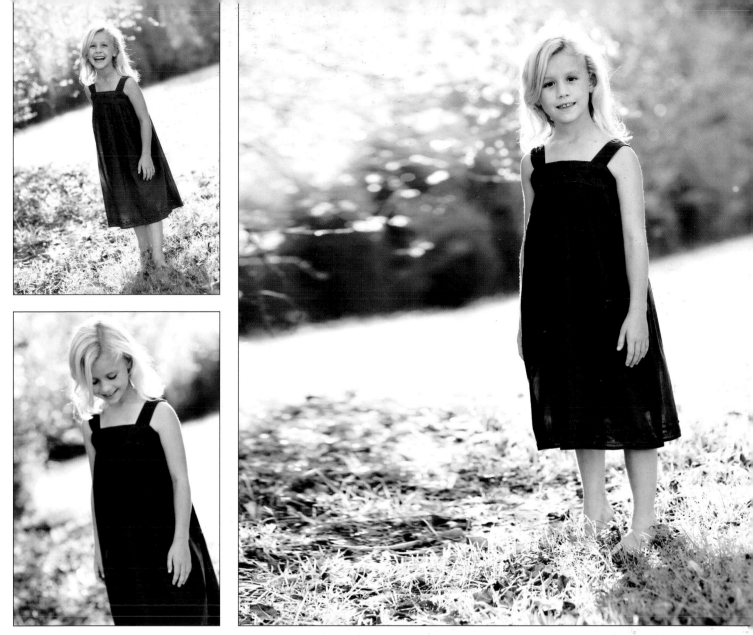

With a bit of subtle coaching, you can get a variety of natural poses and expressions.

tioning their chin a bit more out and down to avoid an unnecessary double chin. It's a natural response to laugh and throw your head back and shoulders up, but this can create the illusion of more girth around the neck and chin area. You can easily avoid this by offering a few quick tips to the subject(s) before the shoot even begins.

4. Consider showcasing the beautiful S-curve of your subjects. A completely straight body facing the camera head-on can tend to look stocky. Creating some turns in the form, on the other hand, creates a look that is more fluid, graceful, and attractive. Simply turning an individual to the left or right can create this S-curve quite easily.

5. With children, you typically want to get down to their level, but sometimes shooting from above—with their gaze cast upward toward the camera—can really accentuate their striking eyes.

Organic Directive Posing. The concept of organic directive posing is simply to combine the formal pos-

ing techniques of traditional portraiture with the free-form feel of contemporary photography. Much of the time, you can just position yourself to capture the sub-

ject in their natural state. In other cases, especially with family portraits, it helps to start with a pose that looks good—one that works well from a portraiture perspective—and then let the organic part take over by capturing images while the subjects readjust the pose to what is more comfortably "them."

With this type of posing, your subjects are engaging in movements that are natural to them; your job is simply to readjust, as needed, along the way. Maybe Suzy loves spinning, so you capture three great variations of her spins for a high-energy triptych—but five minutes later, she's still going, and now you want to move on to another activity or look. Go ahead and give it a few minutes. Eventually she will find (or allow herself to be directed to) another interest. Let's say it's looking for acorns on the ground. Utilizing the

Getting a portrait with both of the twins smiling at just the right moment (below) required a little help from Mom and Dad (left)—and a little organic directive posing.

fundamentals of organic directive posing, you would start by capturing the soft look of her head tilted downward. After you get that first image, you can then coach her a bit. Gain her attention so that you can capture a direct look, then seamlessly encourage her to look upward (maybe by striking up a conversation about where the acorns might be coming from). As you do this, move yourself slightly left or right, so that she is now composed in a new and interesting way.

The same would be true for, say, a portrait of parents with their one-year-old twins. Maybe the only time you can get them to laugh together is when they are thrown up in the air at the same time. Their best smiles may be right afterward. To get the photo you want, have Mom and Dad toss and catch the twins, then stop in a basic pose you decide on. When you get the timing just right, they will still be in that great moment when they all turn to face the camera.

Oftentimes, you will find that clients appreciate and desire one image of their family that is a bit more traditional. This doesn't mean they want to look rigid or formal, though. Most people still want an image that captures them as they really are, day to day—just in a little bit more of a structured and coor-

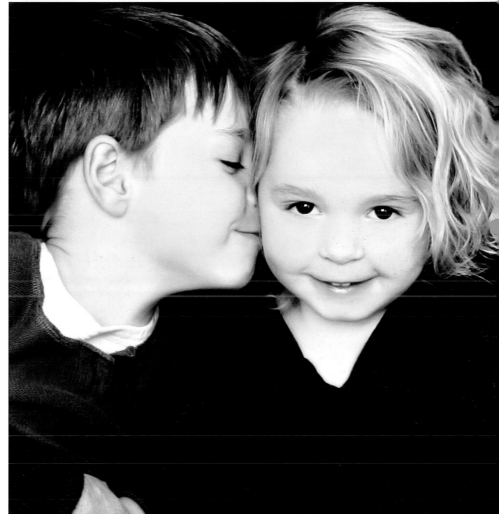

And don't forget to capture a few images highlighting what life is *really* like!

dinated way. Using organic directive posing, this slightly more traditional image can still look casual. Just arrange your subjects for the traditional portrait, then continue to photograph them as they relax into the pose and infuse it with their own natural body positions.

Environment

When choosing a location for creating portraits, there are several things to keep in mind. The most common location for many portraits is a studio, utilizing a studio backdrop of white seamless paper, muslin, vinyl, drop cloths, etc. A great many contemporary portraits still utilize the simple studio backdrop. If you are feeling more adventurous, you can take advantage of a whole wide world of backdrops and lighting scenarios by taking the show on the road—shooting in urban environments, parks, or wherever else your imagination leads you. Deciding which choice will work best for you and your client will be covered in chapters 5 and 6. For now though, let's look at some of the choices you have when selecting locations.

Outdoors. What are you looking for in an outdoor location? The answer will depend on your objective for the given shoot.

If you know that the emphasis will be a very clean, focused image of the child, you only have to look for good outdoor lighting options. It hardly matters where you are at all. Just find an area that is open, yet generic, so that nothing distracts the viewer from the subject. You can also use focus to visually separate your subject from the background, reducing its prominence. To do this, place your subject at a distance from the background and/or shoot with a narrow depth of field. This will soften any outside distractions and keep the focus on the child.

Were these images taken in a meadow? On a baseball field? In a backyard? It hardly matters; to maintain the emphasis on the subject, the background was kept completely clean and generic.

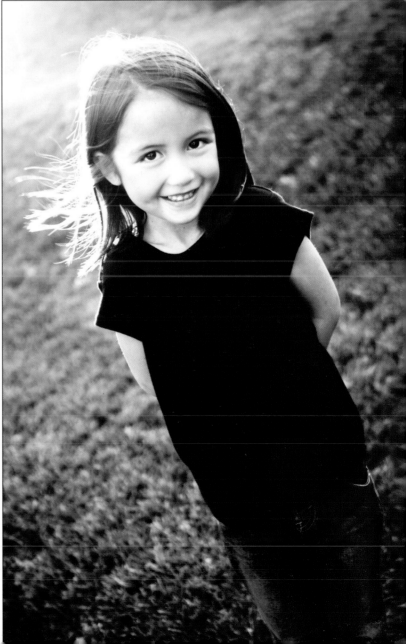

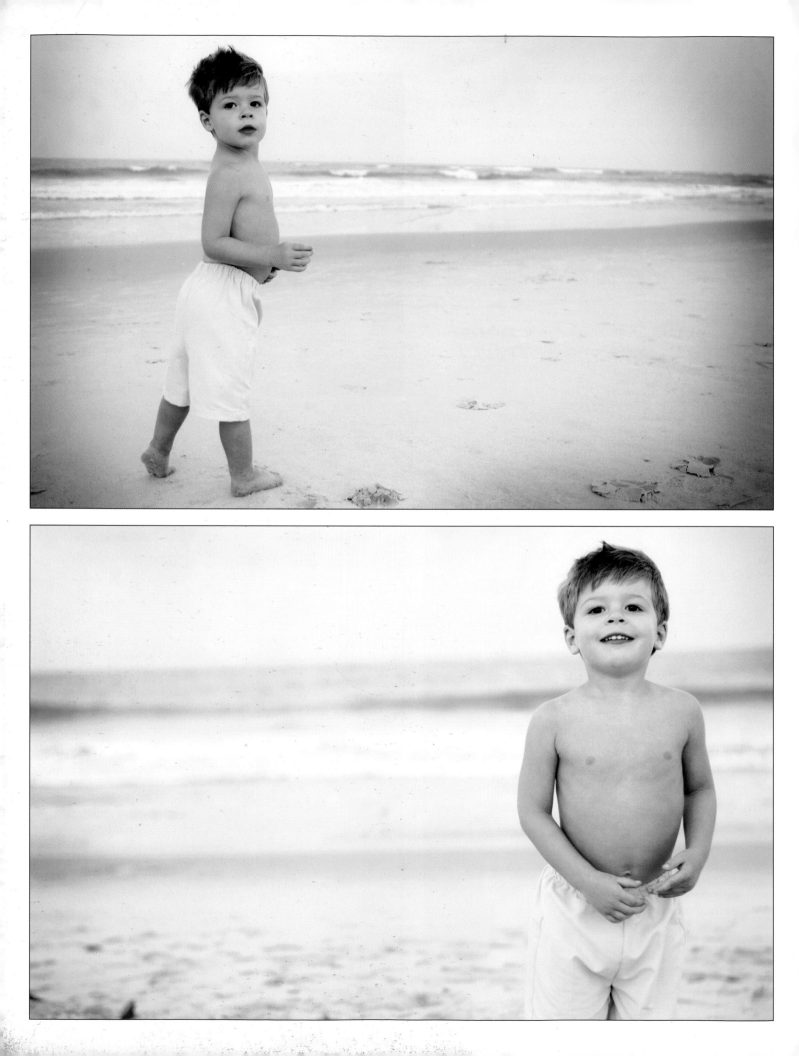

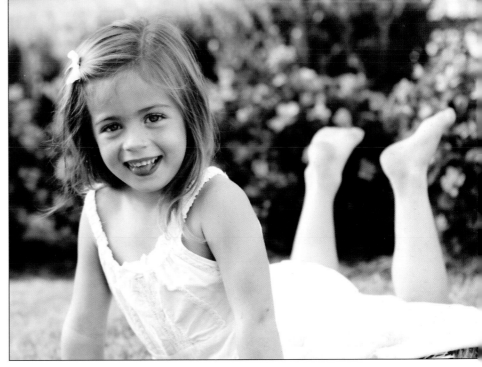

FACING PAGE, TOP—Here, there's some wonderful perspective between the subject and the ocean—it seems to go on forever (and he does not look very sure about it all). FACING PAGE, BOTTOM—This is a similar image, but with a different flavor. In this shot, you can see the boy's excitement and anticipation about the huge playground of water behind him. Here, he seems to *own* the ocean. TOP RIGHT—In this image, the flowers were a beautiful complement to the young girl's rosy cheeks and natural-looking sundress. BOTTOM RIGHT—The texture and curve of the hammock, along with the natural backlighting, were necessary components of this image and enhance its overall composition.

In some cases, you very much *do* want to showcase the location and the child's relationship to it. In these cases, that relationship can be represented in a variety of different ways. Let's take the example of a beach portrait. When photographing a child and the ocean, you might choose to contrast the small child with the vast ocean. Alternately, you might want to show how excited the child is about their trip to the beach—eager to play and explore this new environment.

Sometimes, it is desirable to include the background simply because it presents an interesting and attractive background for the portrait. It might complement the colors in the subject's outfit, add good leading lines or framing elements to the composition, or feature an interesting texture that appeals to you.

The Urban Setting. A common practice in fashion photography is to photograph beautiful people in less-than-beautiful surroundings, capturing the distinctive juxtaposition of two worlds colliding. Utilizing an urban background for children's photography is a similar take on this compelling contradiction.

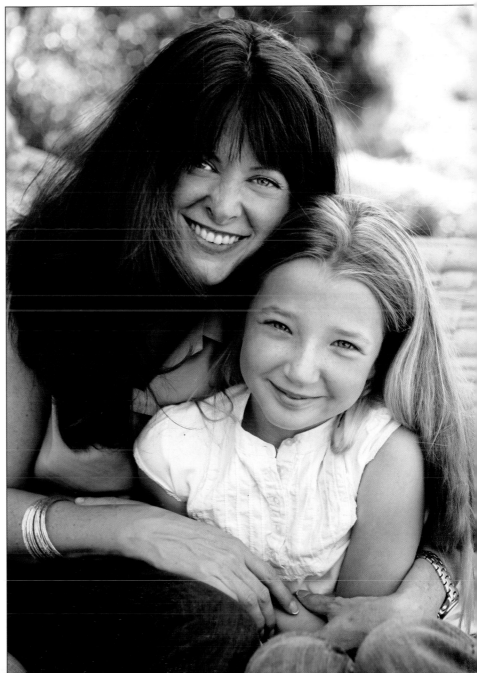

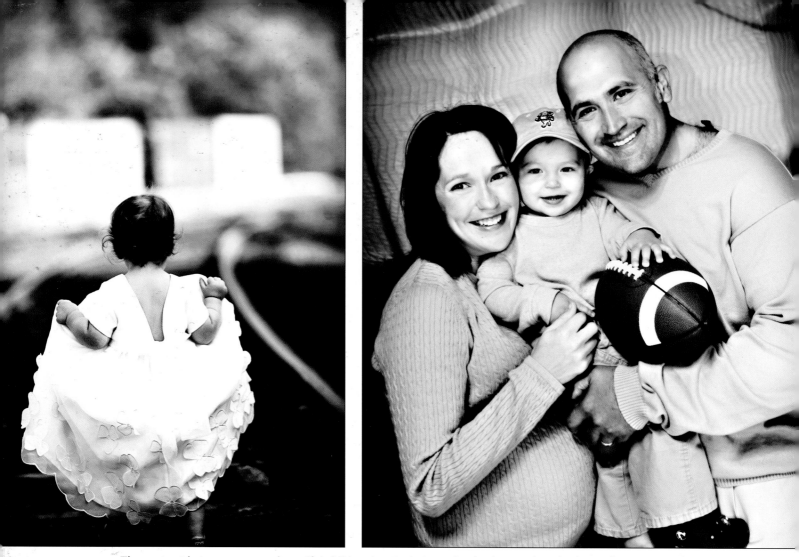

LEFT—The contrast between a sweet, beautiful child and a rough, imposing background can be compelling. **RIGHT**—Shooting inside of elevators, which act as little natural-light studios, can be very effective—and kids will usually crack up watching the photographer try to jump clear of the doors. **FACING PAGE**—Architectural elements can add texture and leading lines to your portraits

Shooting in an urban setting will mean different things to different people; it all depends on where you live. An urban shoot in New York City's Times Square will be very different than an urban shoot in Gahanna, OH, no doubt—but you can look for the same things. Think about buildings, windows, doorways, and streets. Look for height, lines, and light. Seek out sleek shapes, boxy structures, opulent textures, and activity—the buzz of city life. You will want to incorporate many of these elements into your shoot.

There are, of course, some limitations when you are dealing with kids. For example, plopping a child in a back alley at night amongst the cigarette butts and broken beer bottles is probably not a wise move (even

if the shot might be pretty cool). An excellent time to shoot in an urban setting with children is in the early morning. At this time of day, the light is typically more diffused and you usually have fewer people around. The streets also tend to be cleaner. Of course, morning also tends to be a better time for children's moods anyway.

The variety of colors can be plentiful in urban environments—sides of buildings, painted walls, iron gates, large signs, advertisements, and doorways can all act as awfully striking backdrops. When working with bright colors, though, be sure to pay attention to color casts. Vibrant colors can reflect onto your subject if you are not careful to separate them from

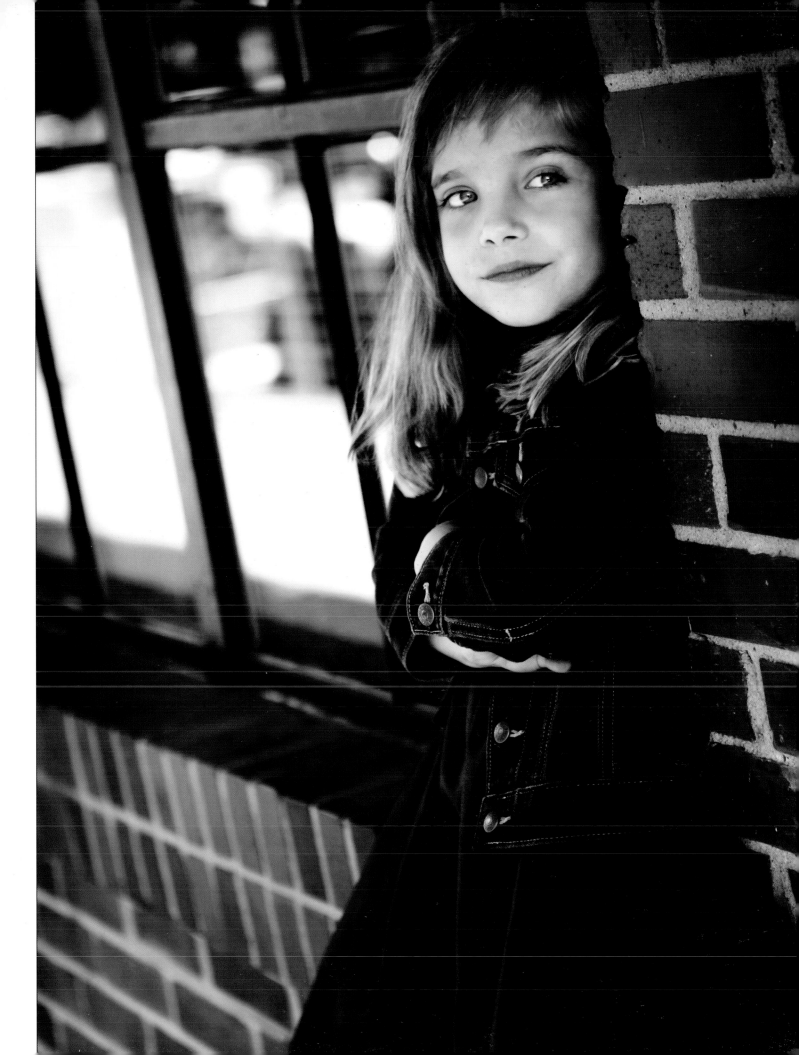

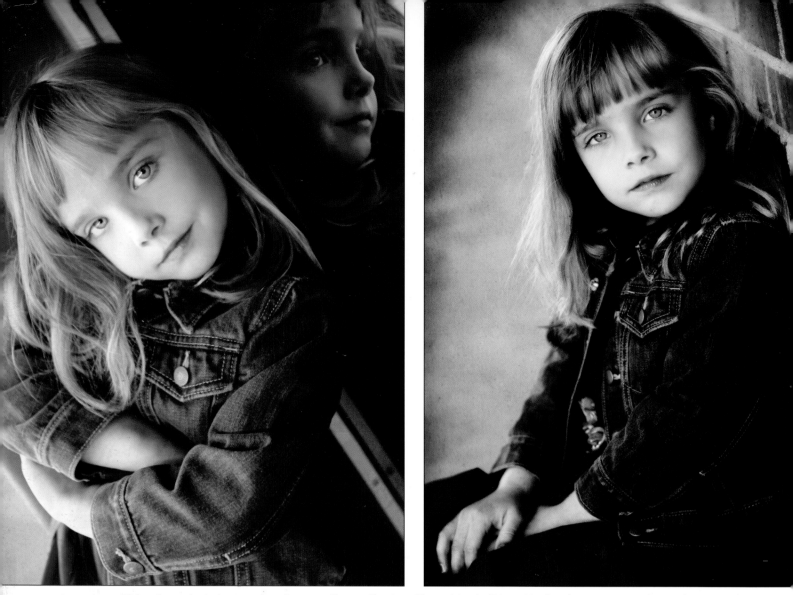

LEFT—This mirrored window produced an excellent reflection. The subject's "Mona Lisa"-style expression also grabs your attention. It looks like she has two different expressions in each of the images. **RIGHT**—The graininess of your surroundings can add a rough edge to your images.

the strong colors or to shoot in a direction that brings in a neutral light.

Try to mix it up as you shoot. Take some photographs that emphasize lighting and angles, paying strong attention to framing. Think about positioning your subject against a building with an interesting shape or a rounded roofline, composing your image to include a wider view of a more vertical image. Practice a liberal use of tilt to get a feel for a different sense of movement in the structure. In architectural settings, borrow from the rougher graininess of your surroundings and blend some texture into the image.

Also, be sure to look for windows and reflections. You can achieve some exceptionally thought-provoking pieces with natural reflections and interesting subjects.

Consider using people as an additional background prop. Start by photographing your subject with an empty urban landscape in the background, but then look for a hub of activity to add some buzz to your composition. With a large group of unidentified, unrecognizable people behind your subject, you can add a little spark to the feel of the image.

RIGHT—When shooting in an urban environment, look for colors that complement your subject's attire.

FAR RIGHT AND BELOW—Start with an image that keeps the focus on the subject, then look for ways to pull in some buzz from the background activity.

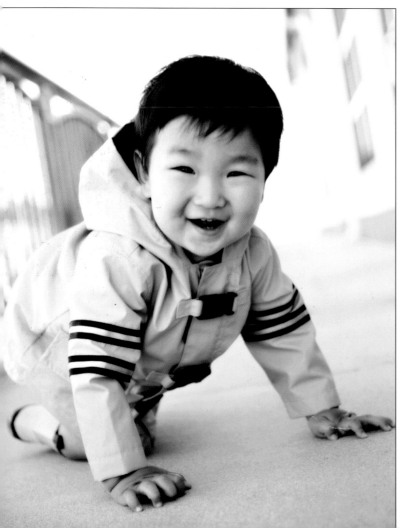
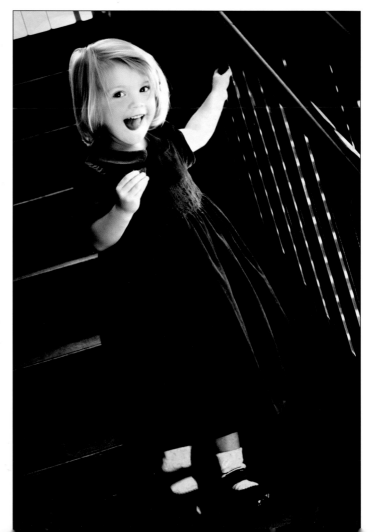

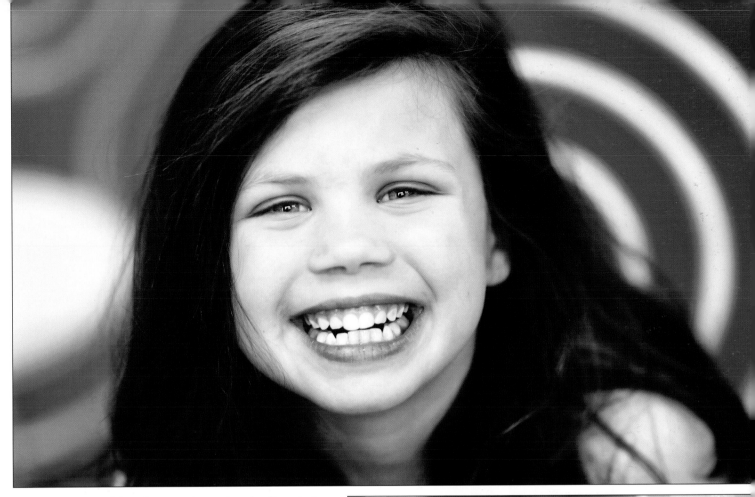

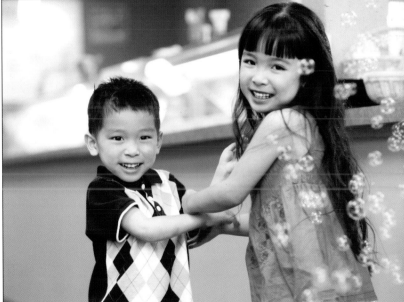

FACING PAGE—Metal benches, tracks, poles, loading docks, garage doors, and stairways can be fantastic structures to play with. **ABOVE AND RIGHT**—When out and about, pop into restaurants and shops.

The Park. Meeting at the park is a great option when photographing kids—and these tend to be high-energy shoots. Depending on the landscape, you'll find a great variety of backgrounds to use. Additionally, one of the best parts of shooting in a park is using creative lighting. Shooting in a shady spot with the light behind you is a good option. Using light filtered through the trees can also be striking.

For park shoots, you don't have to be stuck on a bank next to a pond. You can still use the elements in nature to beautiful effect, even with a "run free" strategy (which is typically successful with kids—especially if they run back!). Much of what works in contemporary photography is a simple adjustment in strategy. Instead of (or in addition to) photographing the child standing beside the tree, you might have them climb the tree. Instead of sitting the kids on a bench, tell them to wrestle, super-snuggle, or interact in some other way. Encourage "attacks" on Mommy and Daddy and suggest lots of swinging, dancing, running, teasing, and hugging.

Find great framing elements and get inventive with the elements that are all around you. Use leaves and flowers and acorns—whatever is available. Shoot from the ground, shoot from a high angle, grab a unique perspective and put a twist on the standard "session in the park."

Make use of any natural elements you can incorporate into your images. Archways are typically plentiful, as are low-hanging trees. S-curves that are part of nature or man-made can bring in some elegant lines. And, of course, there are great opportunities to utilize a variety of foregrounds in your compositions. Whether they are soft and leafy, or strong and striking, foregrounds can add context, interest, framing, and eye-catching perspective to your imagery.

The Home. A great place to shoot portraits is at the client's home. Sometimes you will walk in and find that the house is set up like it's ready for a commer-

BELOW LEFT AND RIGHT—Look for different ways to use each scene. Don't just photograph the child next to the tree, try putting him up in it. **BOTTOM LEFT AND RIGHT**—At your park sessions, encourage lots of interaction and silliness.

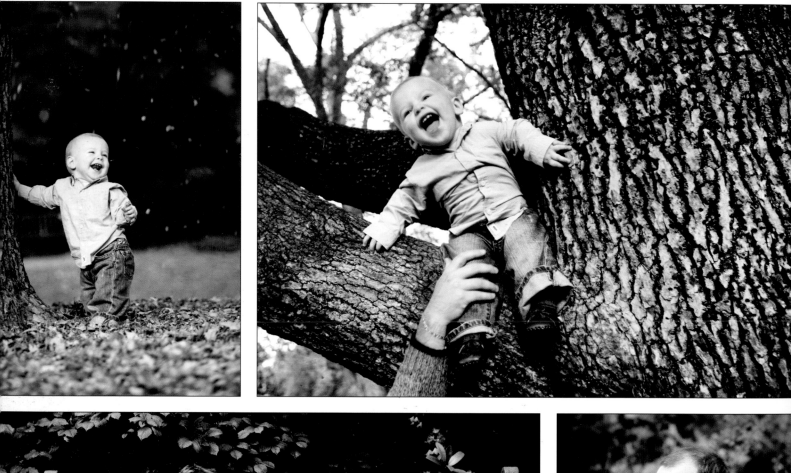

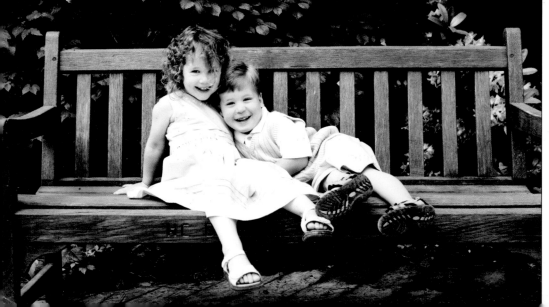

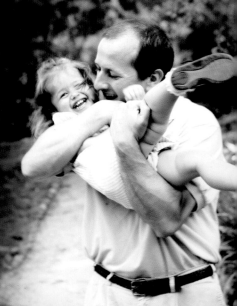

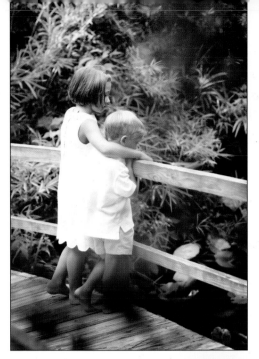 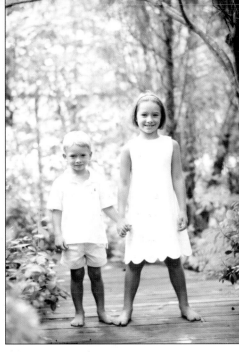 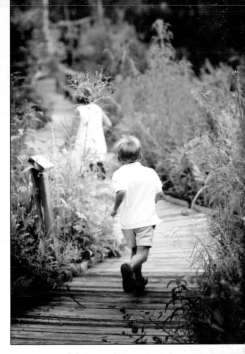

ABOVE—S-curves, leading lines, foregrounds, and framing elements can all be found in most park settings. RIGHT—In complex environments, a wider view can be your best option for an appealing portrait.

cial shoot. You can just plug in the models and create photographs that look fabulous. Other times, you will walk into a home that looks great from a design standpoint but is not necessarily optimal for photography. For example, a big style in house design is the very traditional look, with lots of bold patterns and deep colors. These look great alone . . . but not so great when Mom wants an image of Johnny in his plaid sweater amidst the swirls, checks, and fleurs-de-lis! The following are some tips on how to handle this:

1. Simply explain that the combination of colors and patterns they used works well for their home, but they will reduce the attention you

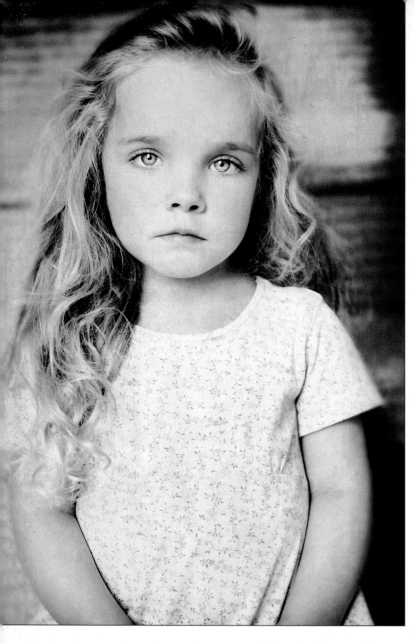

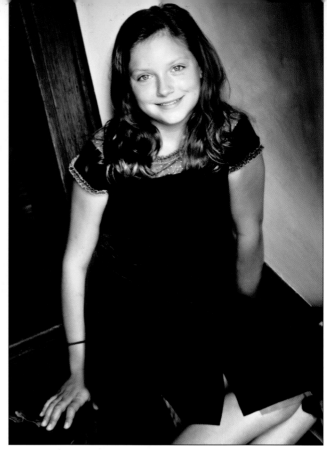

LEFT AND ABOVE—Find all the spots in the home where you can photograph your subject with an uncluttered background. **FACING PAGE, TOP LEFT**—Tight shots with a narrow depth of field can work with almost any background. **FACING PAGE, TOP RIGHT**—Go low! Play on the floor. Shoot under the table, piano, or desk. **FACING PAGE, BOTTOM**—There were only a few of these brightly-colored circles on a section of the playroom wall. By using them to frame the brother and sister and shooting low to pull in as much of the ring as possible, the desired effect was achieved. Framing, bright colors, great expressions, and compelling posing combine to make this a fun image.

want focused on your subject in the overall composition of your shot.

2. Gently talk them into changing Johnny's clothing into something simpler so that, at the very least, he is not competing with his surroundings for attention.

3. If the patterns and colors all look a bit jumbled and distracting, consider shooting more in black & white to minimize and tone down competing colors

4. Another option is to pull back for a very wide shot. Décor objects look beautiful in a home, but they often seem like too much when pho-

tographed, so go for an overall view. Your subject may only be a small part of the image, but you can produce a photograph that show-cases the context of where the subject lives and their relationship to that space.

Start thinking differently about what you're looking for when shooting. Your goal should be to show the clients their home like they haven't quite seen it. One of the classic features of the contemporary look is shooting wide open, creating tight focus on the subject and a blown-out background. This approach is well suited to minimizing a potentially distracting en-

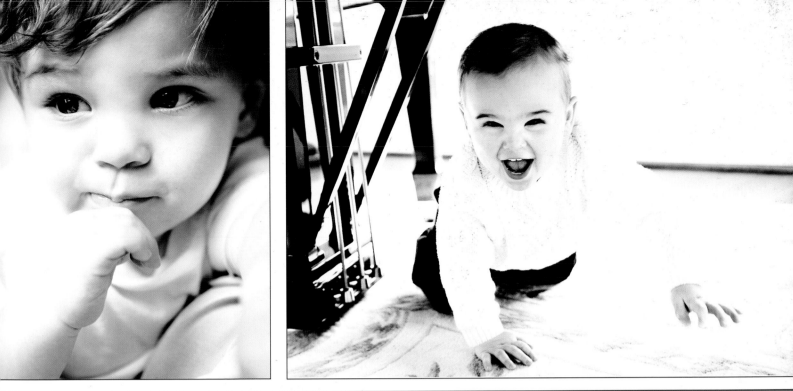
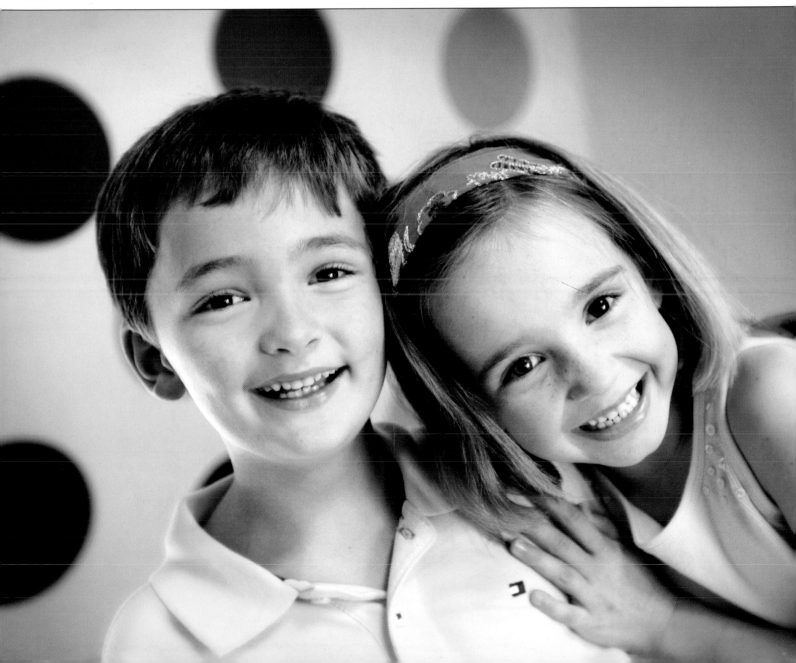

vironment. Bring your subject to doorways, work under a calm window, or shoot up a staircase. Find all the spots in the home where you can cleanly photograph your subject. Let your client see that their home can look just a good as a studio designed for editorial images.

Don't, of course, ignore all the sweet spots that make their home unique and form an important part of the children's world—areas like playrooms and tea tables. When photographing these subjects, strive for unique perspectives and play with wide angles. Also look for out-of-the-ordinary décor, an element that may blend in to a room but adds something interesting as a standalone.

The Studio. The studio has typically been a more "standard" place for imagery. Not anymore. You can get mightily creative in a studio—and you should! If you find yourself constantly putting your subjects in the same spot, with the same backdrop, and using the same lighting system, you can quickly become bored with your job—a job you used to love.

Stay fresh with how you shoot. Use creative lighting, play with unusual backgrounds, try new colors, new surfaces, and new reflectors. This doesn't have to be expensive play. You can go to a local hardware store and find loads of options: buy some fun new paint colors, a brush, and a thin piece of plywood (or foam core, or masonite, or Styrofoam insulation), and you've got unlimited possibilities.

If you have a large window in your studio and can shoot with natural light, this provides even more opportunity to play. You can shoot against the window,

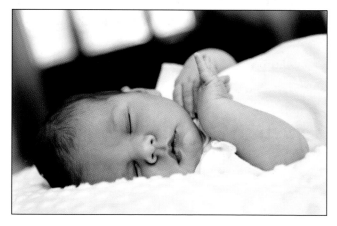

ABOVE AND LEFT—Your initial urge might be to go in tight on this gorgeous ten-day-old face, but don't forget to pull back to include the beautiful architectural element of the arched window—a very different image.

from the window, or along the window. You can also use just overhead lighting, reflectors, and window light for a varied look and feel.

A Cool Location is Best, But . . .

Once you get comfortable with lighting, knowing when it is best to separate your subjects from the background, and seeking out uncluttered surroundings and framing compositional tools, you now have the unbridled freedom to shoot pretty much anywhere with strong results. You may find that you need a couple more items of gear in your bag to do so, however.

A collapsible reflector is a good addition to your kit and can be used in a number of ways. You can use it to open up shadows on your subject or create additional catchlights in the eyes. It can also be employed to block contrasty light from overhead or to soften a too-sharp light source. It can even be utilized as a small drop—helpful when you want to place little Suzy in the grass and Mom is concerned about stains. When collapsed, it acts as a small "seat" that can typically be hidden in the shot. You can probably think of another five uses when you are out and about yourself!

A small video light is another helpful piece of equipment to have on hand. This is an exceptionally portable light source that can be used as an additional fill light on location. Be aware, however, that they are notorious for low battery life. Save yourself the hassle of limited usage and buy at least two.

Sometimes it helps to bring a small backdrop along in case the backgrounds you encounter are difficult to work with. The most portable options are collapsible backdrops, small muslin cloths, or even sheer curtains. The sky is the limit on what you can use in dire situations—just be sure to keep it as simple as possible.

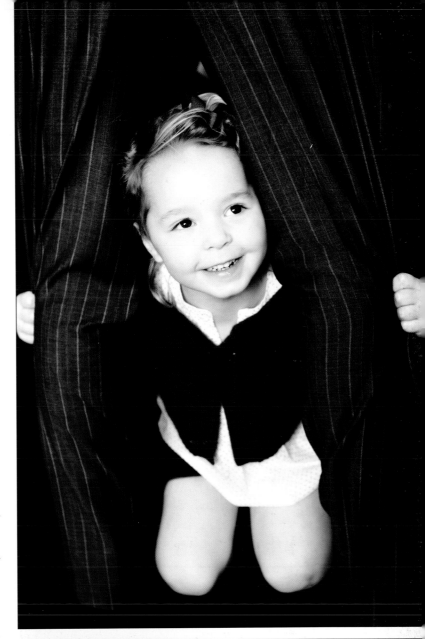

TOP—Use blankets and pillows, cloths, bedding, Dad's legs— whatever works for the image. **BOTTOM**—Sometimes the best images in the studio happen when children have just completely pooped out in the most dramatic of fashions.

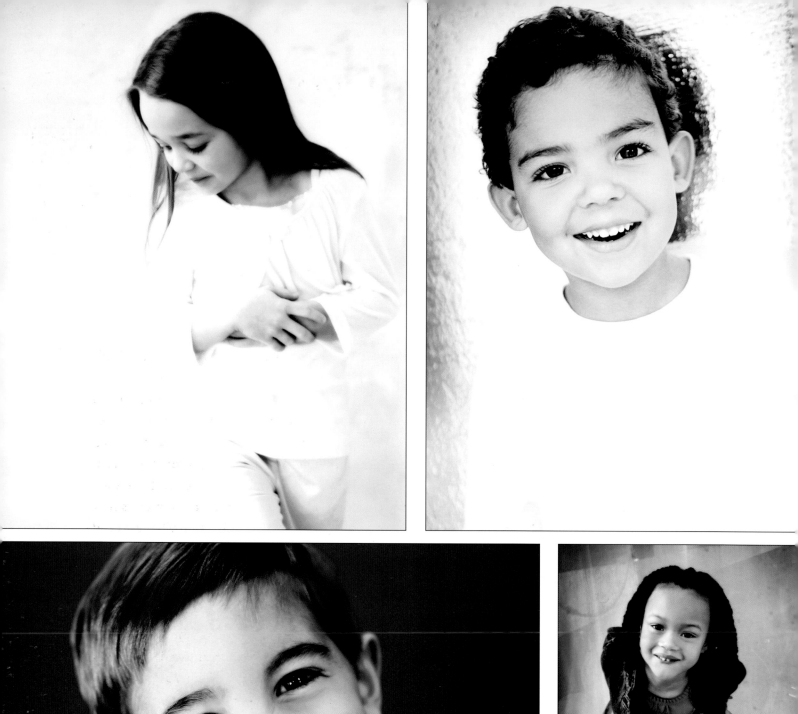

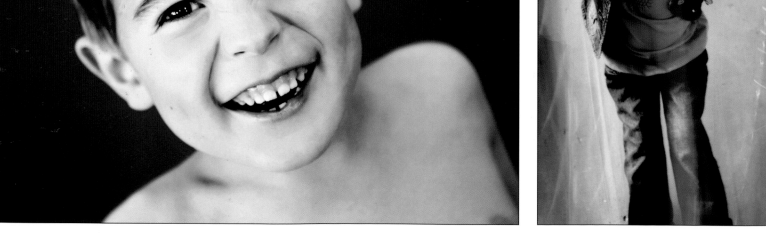

TOP LEFT—Used as a background, painted styrofoam insulation (which can be purchased at any home building supply store) adds great texture. You can determine how subtle you want that texture to be by how close you place the subject to your background. **TOP RIGHT**—The flip side of the styrofoam insulation is a fun metallic. **BOTTOM LEFT AND RIGHT**—Try vibrant solid colors or merge two boards together to achieve a funkier look.

4. The Actual Shoot

Preparing the Client and Learning Who They Are

Once you book a session with a client, be sure to collect their session fee in advance. That way you can ensure that it is okay to block that time off on your calendar and not make it available to other clients.

With that done, it's always nice to either walk them through what to expect next or to send them a detailed package of some sort (physical or electronic) that covers pricing information, addresses various product possibilities, and offers them a solid overview of what's next. This may also include a tutorial on wardrobe selection, a description of the viewing

> *Once you book a session with a client, be sure to collect their session fee in advance.*

process, things to consider prior to the session (helpful hints for a smooth session), as well as some information to get them thinking about *after* the session: album purchases, where they will hang their pieces, what kind of gifts prints they may want to purchase for others, etc. Basically, communicate everything they need to know so that by the time the session occurs, they will be prepared and you will move seamlessly into the consultative sales session afterward.

As you talk with your clients, ask a lot of leading questions. Try to evaluate the "types" (in quotes because no one is ever just one type of person!) of children they may have, so you can be prepared. What are their favorite things right now—songs, TV shows, books, toys, etc.? Will the two children in the family readily curl up together for a photo or will there need to be a lot of coaxing to make that happen? Should we plan to break for a snack at a certain point or will that disrupt the flow and effectively end the session?

Why the Location Can Make a Difference

Children's Personalities. A great location can add greatly to the overall look of the image, but it can also add to the spirit of the shoot. This goes a long way toward keeping little ones excited or calmed throughout the process, whichever may be more necessary. If you know in advance that your subject is extremely sensitive to her environment, you may not want to plop her down barefoot in the wet grass at a park. She's only going to be further agitated and you'll spend the entire session combating her irritation. Conversely, if you know that a child will be bored in the studio, taking them to a more exciting venue can elicit a liveliness that you would otherwise miss while

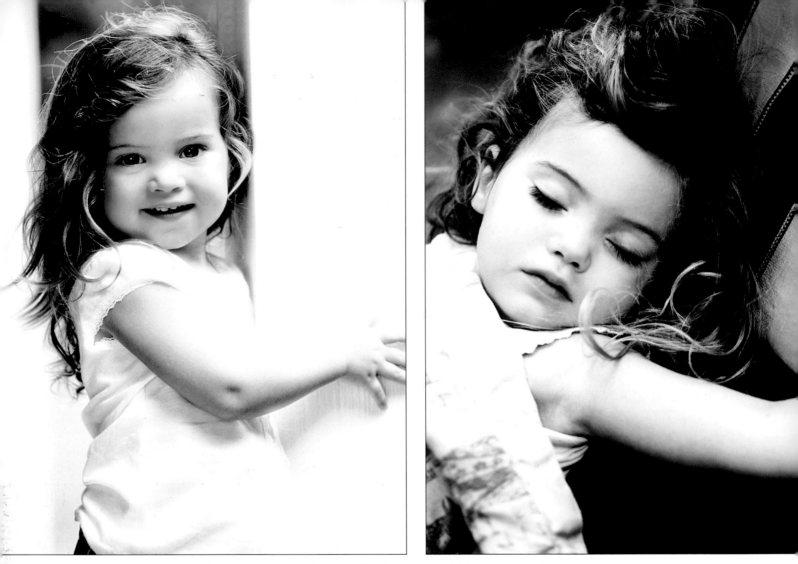

LEFT—This was a wonderful image captured during the shoot. **RIGHT**—This image was shot when her parents brought her into the studio afterward, when she fell asleep in a chair during our consultative sales session. They are both lovely images, but the angelic feel of this image really captured something for me.

trying to corral them within the confines of a white backdrop.

Parents' Personalities. Another factor to consider is the formality or casualness of the clients who are commissioning the work (Mom and/or Dad). While it is true that many of the clients who are drawn to the contemporary look are a bit more easygoing about location, you will still find that some are very concerned about the possibility of inclement weather or particularly sensitive to strangers on location who may be watching the shoot. They may also have concerns about the distance from a potty if their child isn't consistent in that realm. It may be going great with the little ones, but if Mom is tense it will come across in

the family images and eventually bleed into the children's attitudes as well.

Do a Reality Check. Learning more about your clients and their preferences can provide a great deal of information that is vital when choosing the location of the shoot. You also have to be realistic, though, and do your homework (and legwork). There are some things you can ignore in an environment and other things that are going to hurt the overall look and feel of the imagery no matter what you do. A large field of poppies might sound like a fantastic location, but if you are dealing with bugs, muddy terrain, and no natural shading, it might end up being a pretty terrible site for a children's portrait session.

Great Photography: It's All in How You See It

Once you've determined a good location, you can begin to really focus on your subjects and their interactions with not only the location but also with each other. So what exactly are you looking for?

Always keep an eye on expressions, interactions, and movement. Just because you are trying to frame more than one person at a time does not mean you cannot hone in on one great look. If you are photographing two children together, for instance, and one child looks fabulous and the other is completely disinterested, shoot in a manner that will allow you to create a single portrait.

You can use the same eye when viewing locations. Even a background that, at first glance, seems unattractive or cluttered can often be put to good use. By honing in on one small area, you can often make the distractions disappear. Your clients are not booking you to be a picture-taker, they are asking you to use your ability to create photographs regardless of situation. That is why it so important to be able to envision the final photograph through the current scene.

You may never rest in this pursuit. The opportunities to create great photography aren't always limited to moments during the session—in fact, sometimes the best image isn't taken until weeks after the shoot is finished. After-shoot visits to the studio can provide some wonderful candid opportunities, as seen in the images below and on the facing page.

Be Careful—It's Crazy Out There

Have you ever really played with kids? Have you ever kept up with them when they are just doing their thing as best and as fast and as crazy as they can? Do

LEFT—This was a lucky image—that hint of a smile on a newborn infant's face. **RIGHT**—This was even luckier, though. The baby was all bundled up for the after-shoot visit to the studio and I couldn't resist photographing him.

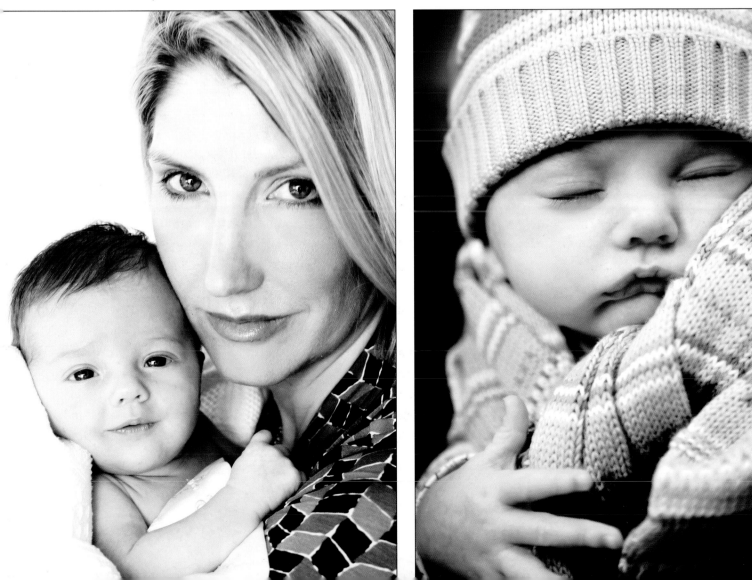

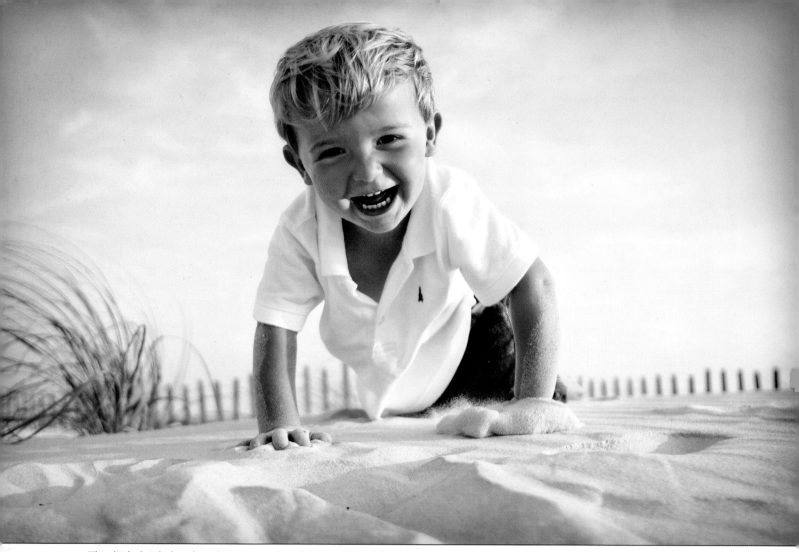

This little boy's laugh as he appeared at the top of the hill was too sweet to miss.

you remember doing that yourself? I've called this section "Be Careful—It's Crazy Out There," because that phrase is what leaps to my mind every time I am engaged in my more active shoots. I could catalog an impressive listing of cuts, scrapes, rips, and bruises that I have sustained to "get the shot." The following are just a few of my adventures—but they give you a feel for what to expect.

There were three boys in my client's family, and I was photographing one of them on the beach when I saw his little brother mount the top of this sand hill (above). As soon as I saw him start to laugh, I knew that this photograph was about to happen—so I slid down on my stomach and captured his wonderful expression. In the process, I also scraped both my elbows, which wouldn't have been so bad except that I

was just beginning a week of beach shoots . . . so I continued to scrape and re-scrape them throughout the week. Add to that plenty of salty ocean water—ouch!

While photographing one youngster (facing page, bottom left) and his two brothers at a park, we tried to balance them on a small bridge that had a steep curve at the top. Their mom really, really wanted an image of all three boys at the top of that curve, but the ten-month-old baby was wobbly at best. I was crouched down with a wide-angle lens trying desperately to get them all to look in my general direction at the same time when the baby pitched forward—fast. Mom was too far away, so I dropped my camera (luckily I had the camera strap around my neck) and lurched forward to catch him. I also ripped my jeans

on impact and limped out of there with a serious bruise and a very dramatic-looking bloody knee. Worst of all, though, I did not get the shot.

Adventures during the session aren't always accidents—sometimes they are the result of targeted abuse. One adorable boy (below right) thought it was hysterical that he could actually "hit" me (no, not hard) and was laughing so uproariously at the fact that an adult was not admonishing him that I got a wonderful expression.

Of course, photographing children doesn't just involve getting banged up, it can mean getting wet—or even soaked, as seen in the image to the right. This

particular beach shoot started on land but got just silly after a tumble into the water. To get the angle I wanted, I had to wade pretty far into the ocean. Not only did I get splashed pretty thoroughly by oncoming waves, I was also soaked from the waist down.

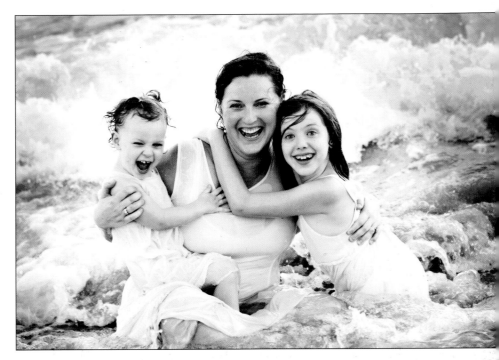

BOTTOM LEFT—I left this park shoot with a serious bruise and a very dramatic-looking bloody knee. **BOTTOM RIGHT**—Getting away with a little "not allowed" play brought some great smiles to this boy's face. **RIGHT**—Chasing the perfect family portrait sometimes means getting soaked.

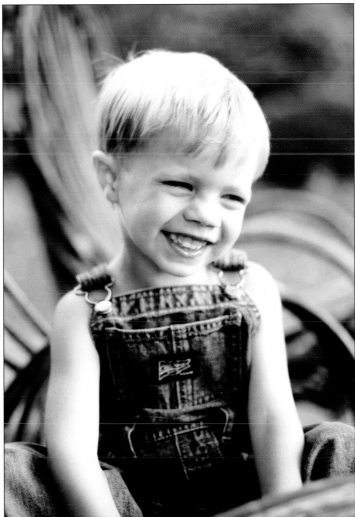

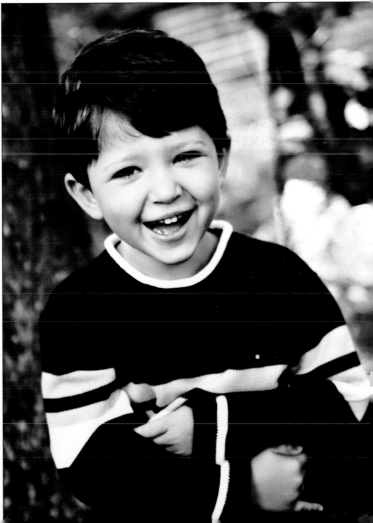

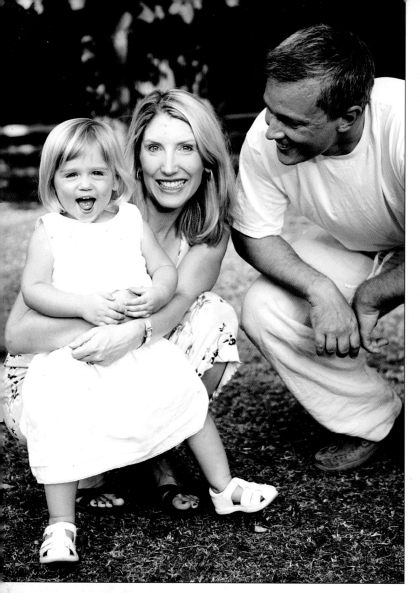

LEFT AND BELOW—Shooting on a farm can mean getting some unusual subjects involved in your family portraits.

BELOW—Oh the things I have to eat (or at least pretend to eat) to get kids engaged! In this case, it was handfuls of leaves.

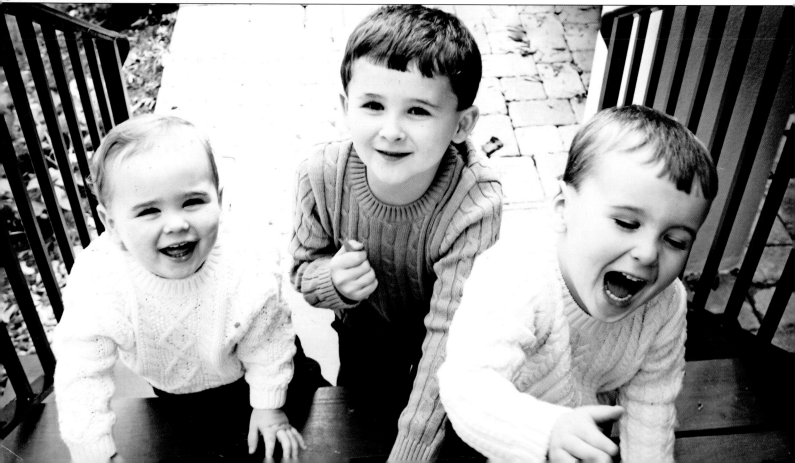

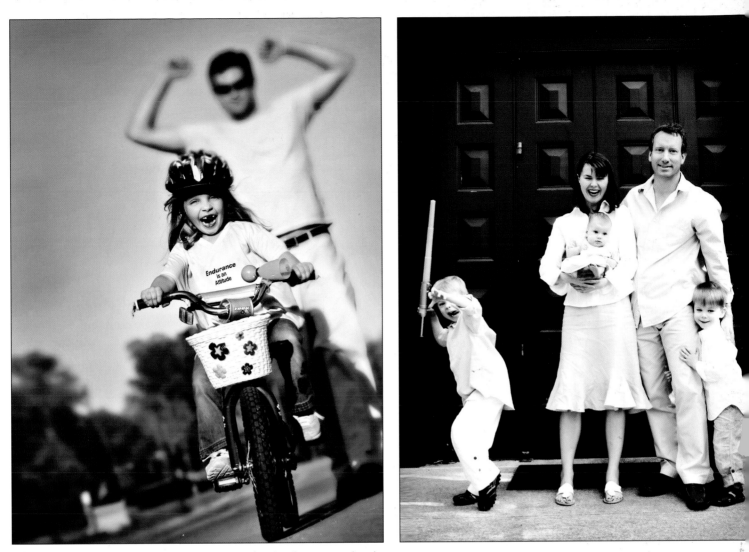

Putting yourself in harm's way is sometimes what it takes to get the shot.

The potential adventures you can have when photographing kids and families on location are almost unlimited. Once, I was photographing a family on their farm (facing page, top). They wanted images with the sheep herding through the gate—and I was up for it, but I couldn't help cringing when I felt the rush of twenty sheep racing around me, splitting up the middle of the herd to pass me on either side.

On another shoot (facing page, bottom), I resorted to "eating" handfuls of leaves in order to get all three children to look my way. Although I threw most of them over my shoulder, I think I did ingest a random stem by accident.

When shooting an image for the cover of a fitness magazine, we wanted to showcase the freedom of biking (above, left). The fanatical look of joy I got on our little subject's face, however, was not because she was in love with biking. It was because I was laying stomach-down in the middle of the road and she was instructed to try to steer right toward me and get me if she could. I rolled to safety about seven times before I got the look I wanted. At another session, this time for a family portrait, a young man charged me with his Star Wars sword more than once (above, right). He never did technically strike me, but only because I was quite vigilant throughout the entire session.

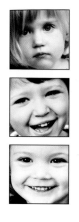

5. After the Shoot

How to Create and Manage a Smart Business Flow

There is a lot of attention paid to managing your digital workflow—and that *is* exceptionally important. But, just as importantly, you need to manage your business workflow. What is the process of work in your business? What happens first, what happens next, what activity triggers what delivery, etc.? What are you telling your clients to expect, and how are you getting from here to there to ensure that happens? How do you keep up with the pace of your business and *not* stay up until 2AM every night editing your images?

How do you keep up with your business and not stay up until 2AM every night editing your images?

Three People At Work. One of the best books out there on process creation and how to successfully manage a business is *The E-Myth Revisited: Why Most Small Businesses Don't Work and What to Do About It,* by Michael Gerber (HarperCollins, 1995). It's a very basic account of a small business owner struggling to manage her business and still live her life—without getting lost in the middle or losing her business.

A great nugget of wisdom from this book is the realization that, even if your whole company is just you, there are three people at work: the entrepreneur, the manager, and the technician. In your portrait photography business, you are most likely the technician. You are the one actually taking the photographs, more than likely editing them, and then delivering them to your client. You are the worker bee. But you are also the entrepreneur; you decided to start this business and you are the visionary who is planning where to take it. Additionally, you are the manager; you are overseeing all the processes, the finances, the project scope, what is due to whom when, etc.

As Gerber explains, you need to be all three people at once. The problem, however, is that all three of those individuals are looking to complete different tasks. The technician in you wants to go take some beautiful photographs and not worry about spreadsheets or your five-year plan. The manager in you needs to invoice clients in a timely manner. That person does not want to worry about editing the five portrait sessions that are due now. And the entrepreneur is scoffing at the rest of you because he just wants to dream, and he wants to dream big.

So you are competing for task completion—the basic struggle of where exactly to spend your time getting business done—and you are struggling with . . .

well, yourself. And small business owners wonder why it is so hard.

Create an Organization Chart. One great place to start with mapping out your business is with a simple organization chart. Map out what needs to be done and who is doing it in your company—even if you are the "who" in every box. This is a great visual cue that can help you decide what jobs are best outsourced and what tasks are best for you to keep doing. Once you have decided who is doing what, you can get more control of your business, your workflow, and—surprise!—your *life*.

Close Out Jobs, Clear Your Head. One important thing to consider when managing your business workflow is the amount of "jobs" you have on your plate at any one time. The more clients you are somewhere in the process with (just photographed them; waiting weeks to meet with them about their order; waiting months to hear their confirmation of order; any delay on placing their print orders, etc.), the more you have on your plate. This is a major reason to keep on top of your business workflow. By closing out client files in a timely manner, you not only clean up your workload, you also clear out the noise in your head—you'll spend less energy trying to keep track of who is where and what you should be doing next with their job.

If you can design a start-to-finish workflow for how you do business and document it in a clean and organized fashion, you are more apt not only to create the most effective system for your particular business but also to follow it more diligently.

Digital Workflow

Probably the most efficient way to manage your time in "back room" activities is to create and stick to an elegantly designed workflow. Get specific and actually write down not only *what* to do but also *in what order* you should be doing those tasks on a daily, weekly, monthly, and annual basis. You will want to create a

workflow that fits your style, but here is a basic system to start with—tweak it as needed.

Backing Up. Start with the most important aspect of the post-shoot: backing up your work. Once you download all the images from your session, back up everything in at least three different places (there are *very successful* photographers out there who swear they back up their images four or five times—so, yes, you have time).

The first backup is, of course, to your computer, in a designated portrait folder. The second backup should be to a DVD, which should be filed by date and kept in a storage unit. Use a marker to note the subject, date of shoot, and that they are the unedited

Once you download all the images from your session, back up every file in at least three different places.

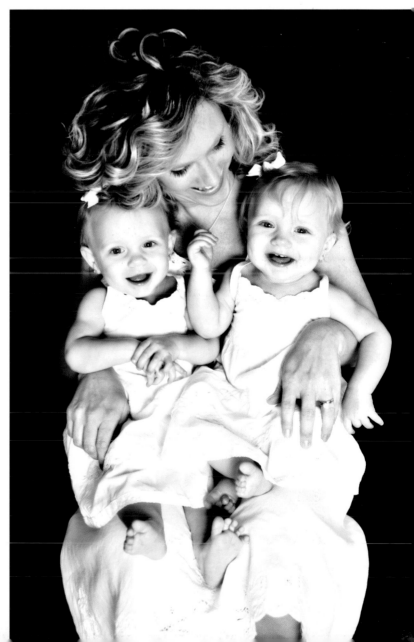

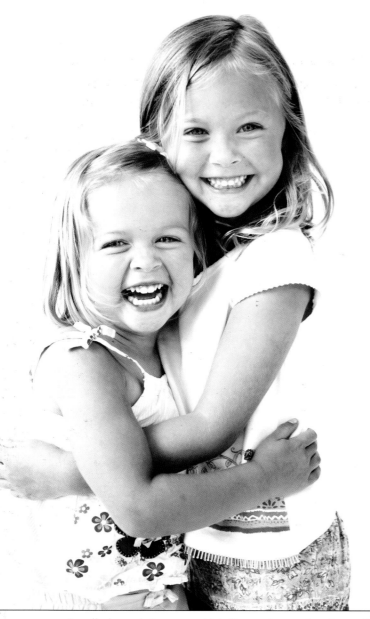

A well-planned storage and labeling system makes it possible to retrieve your images more easily—even years from now.

puter and use it to back up all your unedited proofs, as well as your finished and edited portraits, in a folder labeled with the client's name and the date of the session. A good sample of your file structure is as follows:

Ann Smith 10.03.07
 Ann Smith 10.03.07 Unedited Proofs
 Ann Smith 10.03.07 Final Proofs
Sophia Kendall 11.19.07
 Sophia Kendall 11.19.07 Unedited Proofs
 Sophia Kendall 11.19.07 Final Proofs

Once the year ends or the drive becomes full, unplug it and put it away for storage as an additional backup for your work. Try to keep the one or two drives you may fill in a year allotted to just that particular year. Even if you have plenty of space left on the drive, start fresh with a new one when you start with a new year. This will help you to organize and find your imagery much more easily over the long term.

It is a good idea to store these drives offsite. If you work in a studio that is separate from your home, perhaps you can store them at your house. If you work at home, think about storing them in a lockbox at a bank.

If you do not want to actually backup one more time, there are a number of products and software programs out there that do automatic, sweeping backups for you on a daily basis. You can even do this using online storage, FTPing all backups to a large hosting site. Either way, do not delete the images from your cards until you have these backups in place.

A shared network is another good tool for file security. You should definitely consider getting one if you are in a studio and working with other people, but you may even want to consider a similar product if you are working by yourself. A shared network gives you another opportunity to back up your work to a location other than your computer—and many systems come with a backup process in place for your

proofs of the shoot. Do not add a paper label to your DVD, as they can curl up or deteriorate over time and get caught in your DVD drive. Be sure to place your DVD in a protective sleeve or case before filing it away in chronological order.

Next, back up your files to an external drive that you can unplug and put away at the end of the year. External drives are an excellent additional insurance policy for your work. Simply purchase a nice-sized drive to last for the duration of a year and mark it as such (*i.e.,* "2007 Portraits"). Plug it into your com-

backup! Your shared network should offer plenty of storage space. Take into account not only your current needs but also what you will need in two to three years' time. Then add about 50 percent more just for a maintenance backup option. For example, if you are purchasing two terabytes of storage, invest in an additional terabyte to backup your backup.

Edit Your Images. Stay disciplined when editing your images. Part of what we as photographers love is to stumble across a really striking image—and when we do, we will go off and spend an inordinate amount of time playing with that wonderful find. Suddenly it is midnight and you're barely halfway through with the client's edits.

A better strategy is to finish the whole edit first. Go ahead and flag those killer images that you simply must play with, but don't actually do so until after you are finished with your basic edits. If you do this, you will find that you not only have more time to get creative but that you also feel less stressed because you have a completed session under your belt.

After your initial edit, edit your finished images again. Be ruthless. You want to give your clients a fair shot at choosing their favorites. Don't overwhelm them with too many images from a portrait session. When they are staring wide-eyed at that huge selection of images during your consultative sales session, you are going to wish you'd made it easier on them. More importantly, you don't want to water down the impact of your most striking images by mixing them in with a set of average captures. Learn to really look for the excellence in your photographs.

How many images should you deliver to a client after a shoot? That's up to you. Some photographers will only deliver twenty and that is that. Others will routinely offer 150 to 200. It's your decision, but keep in mind the overall impact of your delivery.

Inclusive editing lets you focus your time on the images you like best from each session.

The Importance of Inclusive Editing. If you are not already editing in an inclusive manner, reconsider your method. To practice inclusive editing means to step

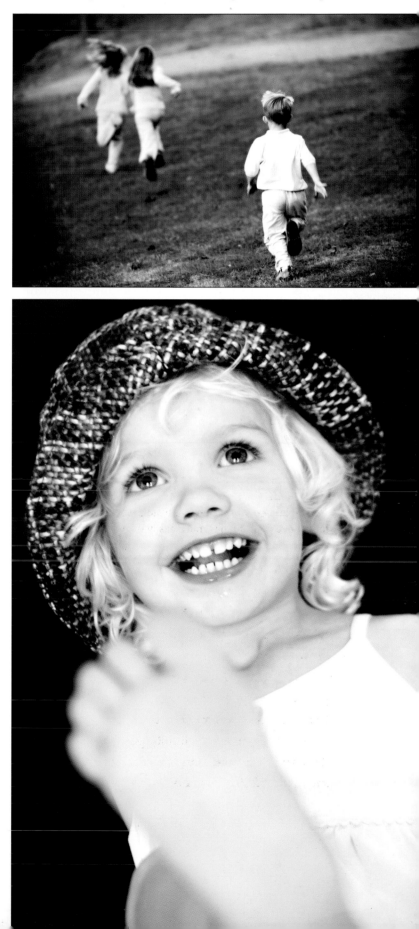

through all of your images and pull the images you want to include, as opposed to taking out the images you do not want to deliver.

Technically, this is a more efficient way to process images, since it allows you to focus on a smaller number of files—after all, you are likely to eliminate more images than you deliver. Afterward, you can simply delete the unselected images as a large group. (You have all the originals backed up, of course.)

Inclusive editing also encourages you to focus on what you like about your photography. You are going right to the images that stand out to you, that have an impact, that showcase the emotion and feeling and beauty that you were after during the session. Why would you want to put your focus on the ones that were anything less than amazing?

This is not to say that you shouldn't spend time learning from your mistakes. Selecting two images with varying exposures and studying their respective metadata files can be extremely eye-opening. Careless bracketing can hurt you more than you know, especially if you forget to bracket back when the situation changes. Just don't get so caught up in studying what went wrong that you lose sight of how much you are doing right.

Backup and Organize. Once you have completed your final edits of the shoot, store these images to both backup locations along with your unedited proofs, again in chronological order. That way, if a client calls you six months after the shoot to request that one black & white image be delivered as a color image, you can find the black & white image and the color original side by side.

Prepare the Proofs. Next, prepare the finished proofs for viewing, whether it is as a webshow, via in-studio projection, an online proofing gallery, or your own customized proofing method. It is still hotly debated in the portrait community whether or not you should offer "picture proofs" to your clients. Many believe that this practice will dilute your sales, as clients "get" the images. You need to decide for yourself what works best for your specific business model.

Inclusive editing allows you to focus on a smaller number of files, making the editing process more efficient.

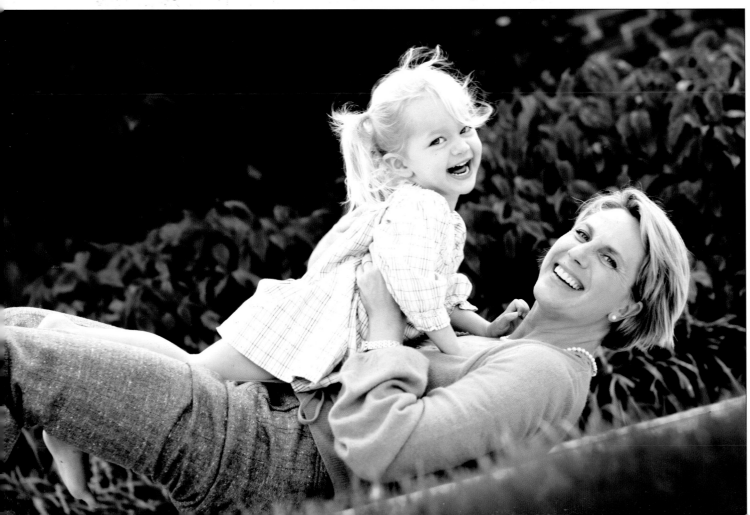

6. The Consultative Sales Session and Image Delivery

An Added Service to Your Clients

Mixing Art with Profit. Let's start with one of the most common objections that photographers voice in reference to conducting any sort of sales session: "I am an artist, not a salesperson." Some take it further, finding the very art of selling their wares offensive: "I am a photographer for the beauty and artistry of the craft. I'm not in this for the profit, for the cold hard cash. I'd rather be happy than rich."

Of course, most of us aren't *that* far down the path, but many photographers do struggle with how to best mix art with profit. And that makes sense. Business and art typically occupy two opposite sides of the real estate in our brains. The general rule of thumb is that those who think in a more right-brained manner are typically more creative and artistic. These are the dreamers, the artists, the musicians, the photographers. Those who think in a more left-brained manner tend to be more logical and analytical. They are the keepers of the business world. Of course, that's not the whole story.

Selling Actually *is* an Art. The real truth about good salespeople is that they usually tend to be more right-brained. They rely more on intuition and they are typically more interpersonal, more genuinely interested in people, and more comfortable interacting with them. These attributes are the keys to good sales

skills. Therefore, as someone who clearly tends toward right-brained thinking, you actually have an *advantage* over the left-brained business types. Even if you are one of the lucky few who are actually a whole-brained thinker, you are still using that creative side.

So, consider for a moment that your concerns about selling might be unfounded. What if you could reconcile your love of art and your (possible) dislike of sales by focusing on an even higher client satisfaction rate—and more revenue to fund your passion? There *is* a way to bring it all together, and it lies in the root of what you may care about most: authenticity.

> *Many photographers*
> *do struggle with how to best*
> *mix art with profit.*

Become an Educator. Nobody likes to be "sold" to. However, most people do enjoy learning more about products or services that they are actually interested in and regard with respect. Finding the balance between informing your client about the options, getting them excited about the products, and maintaining a comfortable relationship throughout the entire process is the goal of the consultative sales session.

Sure, these three images are great alone, but bringing them together as one large canvas piece creates an even more engaging product.

if you frame them together just like this, you suddenly have an amazing piece. Did you see that? If you build a wall collection with seven completely different looks, do you see how cohesively it presents all together?

As photographers, we live and breathe imagery, we typically have a strong hand in design (such a significant part of composition), and we can see how pieces work together in a most pleasing way. If Mom is an accountant and Dad is a systems engineer, they are not working with images and design every day. Therefore, giving them the best possible service means not only shooting their images beautifully but also showing them how to present those final works of art for maximum impact.

As you can see in the above scenario, selling shouldn't be about pressure. Think about how you felt the last time you were in a situation where you were getting "the hard sell." Much of that process is a numbers game; after enough pushing, eventually somebody is going to buy. But that doesn't do much for long-term relationships. It does even less for real-time referrals—and word-of-mouth about your business is about the best marketing you can get. Therefore, it may actually be more lucrative in the long-term to close a small sale with a client and have them leave happy, sharing their excitement with friends and family, than to close a large sale that left them feeling pushed upon or uncomfortable.

That being said, your role should never be reduced to that of an order-taker. Many intelligent, art-savvy

This is an opportunity to fully inform your client of what you can offer them, to relay to them exactly what they can do with the photography options they now possess, and to do so in a manner that is upbeat, emotional and "above board"—making it comfortable both for you and for them.

Let's consider a typical situation. When clients are looking at their sweet baby's face, they usually express something along the lines of, "They are all so good, I don't know where to start. I can't buy them all!" Many parents genuinely appreciate the time and expertise of the photographer in helping to decide what they want to do with the images from a shoot.

Sometimes an image may seem like an easy standout—that fantastic one of little Mimi in front of the surf is a great standalone wall portrait, perhaps. Oftentimes, though, it helps to lay out a client's options and show them exactly what they can do with their prints. Yes, those three prints are quite cute as is—but

clients still do not fully recognize how skillfully a variety of images can come together to create a beautiful triptych, or how cropping here and dodging there and vignetting around this edge can turn a nice image into a stunning one. Even more individuals are not aware of the aesthetic power of a beautifully framed metallic print, or a gallery-wrapped canvas piece that is constructed as artfully as it was conceived. Until you show them the story of their children—nearly leaping off the pages of an expertly-designed portrait album— they are not going to know that they want it. Or how much it will mean to them years later when they show it to their children's children.

So, to sum up, the consultative sales session is an opportunity to work with the imagery you've already created to maximize the entire experience for your client. Draw on your unique expertise and show them something they would truly love to own. Ensure that they walk away with an investment they treasure, not just a product they purchased.

If Salesmanship Doesn't Come Naturally . . .

The truth about sales is that it comes naturally to some, and to others . . . not so much. Some people just seem to have a knack for comfortably intuiting what the other person is thinking, recognizing what they really want (and what they are willing to pay), and meeting them at a point that benefits the salesperson and the client. When this happens, both parties walk away happy with the transaction.

Natural charm is something that cannot be simply packaged, but even if you don't have an innate flair for selling, there are a number of techniques that you can practice to maximize your results.

1. "People buy from those they like." So says Dale Carnegie in *How to Win Friends and Influence People* (Vermilion). The first edition of this book was written in 1937 (!) and it is just as valuable a read today as it was decades and decades ago. The overall premise is simple: be nice. Avoid being negative. Be genuinely interested in other people. Listen to others. En-

You may want to try these images with a chocolate mat and/or frame.

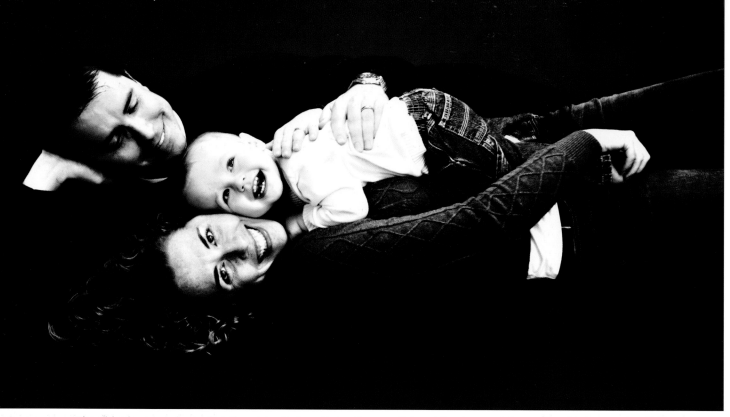

The old adage in sales is that if you don't show them, they can't buy. That is certainly a truism in the creative field.

gage in conversation that is interesting to others. Avoid arguments or the practice of telling people that they are wrong. Admit when you are. Let people vent; try not to interrupt. Be sincere. In photography, this means that when meet with your clients for a sales session, you should greet them with the full enthusiasm you will probably feel naturally after spending time with them during the photo shoot and editing all their images. You have the upper hand of getting to know them a bit better by spending more time with their faces, so feel free to demonstrate the affection that unsurprisingly comes with familiarity.

2. Create the full experience. Remember that the best companies, the best brands out there, are focused on their clients' experiences, not just their pocketbooks. Think of pleasing all of their senses.

3. Remember your manners. Whether your sales session occurs at your studio, the client's house, or a coffee shop, you are hosting this meeting. Offer your client a drink, ask how they have been, and inquire about their day. Tell them that you enjoyed working with them and that you're excited to show them some more details from their shoot.

4. Show them your stuff. The old adage in sales is that if you don't show them, they can't buy. That is certainly a truism in the creative field. In fact, a very common response during consultative sales session is, "I never would have thought of that—I love it!"

5. Invest in some type of proofing software. The difference between uploading all your proofs to an online proofing site and stepping through images in large format with the client can be significant when it comes to your final sales total. Whether you use projection or a laptop connected to a big-screen TV, don't rob your client of the full impact of really seeing their photographs.

Preparing for the Consultative Sales Session

You can hold a consultative sales session in your studio, your client's home, your home, even on a laptop at the local coffee shop if need be. The ideal location for a sales session is in a pleasant environment where the focus can really be on the imagery.

As a portrait photographer, you are in retail sales. (Of course you are also in the arts, but if you want to *stay* in the arts, you are also in retail sales.) To create the desired experience, every great retail store follows certain "rules" when inviting customers to enjoy a shopping experience. These help to stimulate all of the client's senses in a pleasant way. Play soft music in the background, have a more contemporary potpourri in your studio (or, if building codes permit, place scented candles throughout the space). Have plenty of matted pieces and albums out for them to flip through, as well as framed pieces on display. If you are traveling to a client's home or meeting at a location other than a studio, be sure to showcase what framed pieces and series look like with imagery. At your studio, offer them a beverage or a small plate of something to easily snack on—basically, meet all of their sensory needs so that they can fully enjoy the consultative sales experience.

Also, take some time to review the client's images before they arrive. Perhaps create a few suggested pieces for them based on how some images may go together, or showcase how some specific photographs may look when fully framed. Consider predesigning a

The ideal location for a sales session is in a pleasant environment where the focus can really be on the imagery.

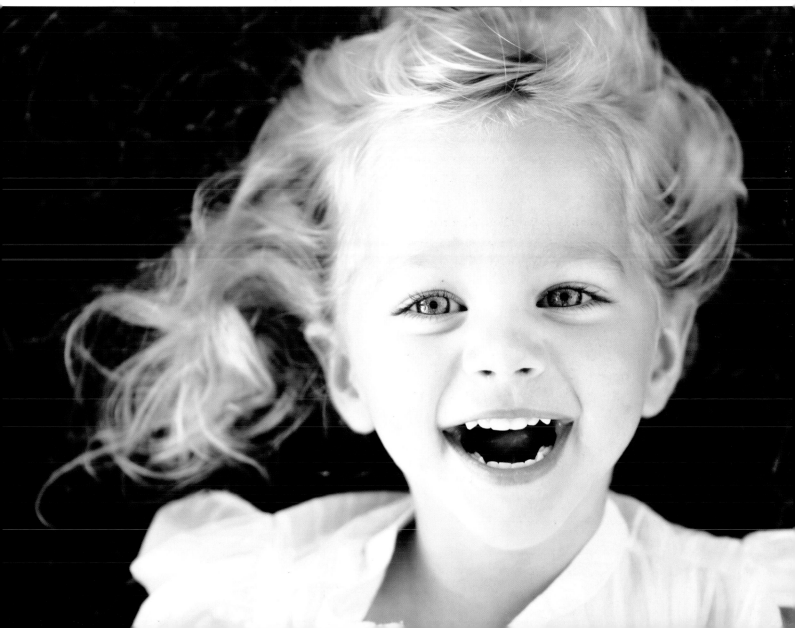

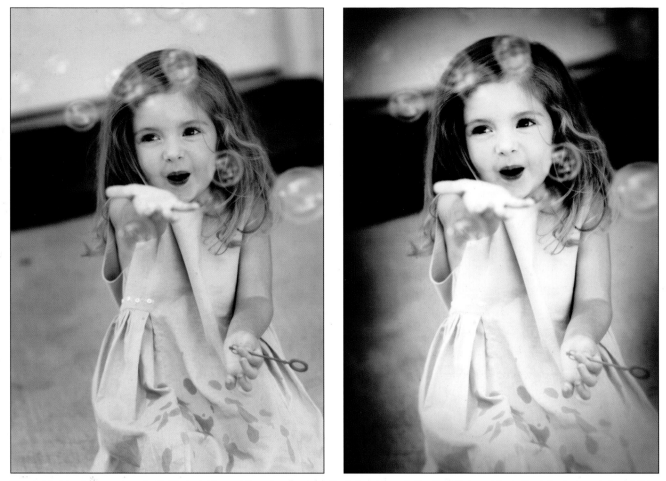

The initial image was lovely (left), but I found the doormat a bit distracting. Adjusting it to a black & white image helped this, as did burning down the bright spots and adding a vignette to really bring the attention to the subject. I also decided on a bit less headroom at the top and removal of some of the darker stains on the concrete that were diverting my attention away from her wonderful expression. Finally, I warmed up the black & white a bit and added a softer look to the overall piece (right).

portrait album or cuing up a custom slideshow from their session. Basically, take the time to gather your thoughts on what direction you think they should take with their photography.

Running a Consultative Sales Session (Without Selling)

It is often easier for a client to make their final selections if they've had a preview of the imagery first. A good rule of thumb is to initially present the images in a more emotive format, like a slideshow. Let the client view the images on their own for a few days (maybe a week or even two, but no more), then sit down and step through them together.

You can start the session with some of your ideas on bringing the images together. Or you can simply begin with the first image in the sets of proofs. There are a variety of image proofing software programs out there. You can work with Photoshop Bridge or iView or iPhoto, but working with ProSelect or Photojunction will typically offer you more sorting opportunities. With ProSelect, for instance, you can view several images at once and more easily upgrade your favorites or rule out the very few that are not overwhelmingly adored!

If you start with sixty proofs, you can ask your client to look at each image with you and simply say whether they love it, like it, or are not interested in

ordering it. As you step through the images together, be sure to offer your feedback in as honest a way as possible. If Dad feels like the image is okay, but you know he will find it to be fantastic if you crop it a bit, take a moment and actually do it. Nearly every time you make the effort to quickly punch up an image or offer your interpretation of how to improve it for final printing, a client will shake their heads at disbelief—and then buy it. This is one of the advantages of digital imaging.

As you continue to peruse images with your clients, it's also a good idea to remind them that it's helpful to add images to their "like it" pile for use when designing framed pieces or albums later. That grouping is a fantastic resource from which to pull when designing multi-image collections of any kind.

Once you have narrowed down the images, you might find a breakdown of: 38 love, 22 like, and 10 "nah" images. From there, it's helpful to first ask the client if they know right away what they'd like to do with those images. Usually, they still appreciate some guidance, but now you know you are working with their most beloved imagery. Stepping through that exercise with a client really puts you in the right frame of mind to feel like you are now partners in putting together the best product for them. This is where you, as a photographer, can start to see the potential for creating great combinations with your client's favorite images. Laying out a few framed pieces is a great way to start showing them what is possible.

It is usually too time-consuming and too detailed of an effort to try to lay out an album with a client by your side, but when they have left you with fifty images to use for the design, your promise to send a proof before the album is produced is usually more than sufficient. You can, however, use templates of a framed series to show them how strips of images will

Ask your client to look at each image and simply say whether they love it, like it, or are not interested in ordering it.

look together in an album. And, of course, you should also have sample albums available to show them.

Once you have determined a final sale—a combination of prints, a wall collection of framed pieces, one

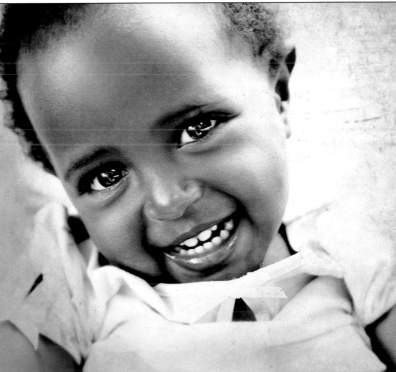

or more canvas gallery wrap images, and possibly an album, too—it's a great idea to have your client step through an invoice before completing the transaction. If this can be done on the spot, great. That is a good time to collect a percentage of the sale before you start finalizing the work. If you need to send them an invoice to review, it's still a good idea to garner a minimum fee before you begin preparing the order.

Only after they have signed off on the final invoice should you commence the work of creating the order for your client. Photographers will usually go about collecting payment differently. Some ask for 100 percent payment up front, others require 50 percent, and many ask for 33 percent. Still others have a set flat fee. Do what you feel most comfortable with, but it is strongly advised that you do not pay for your costs of goods (and time) without payment up front.

The Wrap-Up

Just as significant to the entire meeting is the way you wrap up the appointment. It is not unlike the guidelines put in place for good public speaking, or how to write a paragraph as explained by your sixth-grade teacher. Your meeting should open with you telling the client what you are going to tell them—an overview on how the meeting might best progress. Then, manage the meeting per the guidelines you offered.

Finally, review what you told them—this is the wrap-up. Once the client has made all their final decisions, try to present them with a final invoice while you are still together. If this is simply impossible, you can send it to them later; more often than not, though, that will just extend the process. I referred earlier to the number of jobs you have in process; completing a full wrap-up of the meeting will help ensure that you are closing out each client, rather than keeping them in the loop indefinitely.

Once you have confirmed the order and collected payment, this is the time to state or reiterate the expectations for delivery timelines. Remember that it is better to exceed expectations than to fall short, so build in a bit of cushion for yourself. You never know when the lab will hold up the order, or the frame moulding might be delivered with a chip in the wood, or you are simply busier than you assumed and cannot place the order for another week or so.

Image Delivery

Packaging (It's More Than Just a Box!). Give careful consideration to the packaging you use when de-

Instead of just handing off the packaged prints and framed pieces to your clients, look at the delivery as an opportunity to enhance the relationship you have built with them thus far.

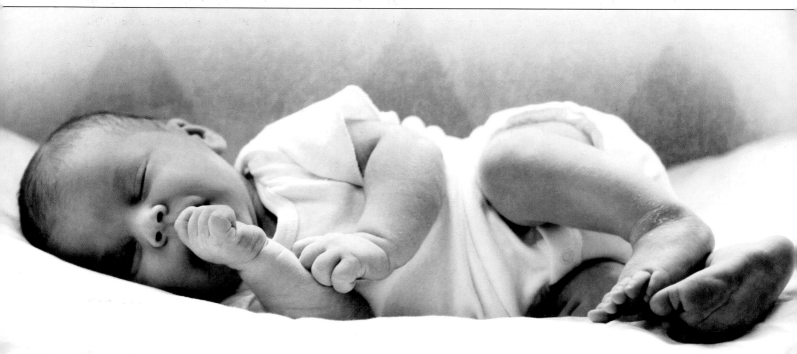

livering prints, products, and albums to clients. You will want to manage your costs, of course, but do realize that you can cover your costs by building a small surcharge into your pricing—and your reputation will benefit greatly from the positive first impression your client has when they see their packaged prints. If you end up paying $1.50 more per package for "the nicer one," think about raising the cost of your prints by $2 across the board. It'll hardly be noticeable—and you're actually making a small profit. Covering costs is sometimes as easy as that.

Some of the best businesses in the industry have recognized the importance of strong packaging (companies like Apple come to mind). You are not just receiving a product, you are paying a bit more for a beautifully designed product that comes in a streamlined, elegant package. And even though you know you are paying a bit more, you feel like it's worth it.

When your clients see their packages for the first time, you want them to feel like the investment they have made is worth it. No, they will not be hanging your boxes on their wall, but they want to know that this has been a quality purchase all the way. What you may consider the "end" of the shoot, the hand-off, is just the start of your clients' time with their purchased products.

The Actual Delivery. Instead of just handing off the packaged prints and framed pieces to your clients, look at the delivery as an opportunity to enhance the relationship you have built with them thus far. If they are coming by your studio or home, invite them to come in and look through the pieces with you. Then, give them hints on hanging the pieces or framing the prints they might have. You will probably find yourself doing this naturally as a good host who takes pride in your work and enjoys spending time with an appreciated client. You might not think of the entire exchange in those formal terms, but that is what is happening.

If you prefer to deliver pieces to a client's home (an especially nice touch with larger pieces), you may want to offer an additional option to hang the pieces in their home or walk through and decide on the best way to put the images together. A number of photographers offer this for either a small fee or with a minimum purchase of some sort.

The end of this cycle
is just the beginning
of a widening circle . . .

The End of the Cycle Is Really Just the Beginning

Another reason that relationship-building matters when delivering pieces to the client is because it's helpful to view this time together as just the beginning of a long-standing relationship rather than the end of the client's shoot-and-order process.

If you have made the decision that you stand behind the quality of your work and all that you deliver to your client, then you know it is likely that you will do repeat business with this client and they will also refer you to friends and family. So the end of this cycle is just the beginning of a widening circle, and it's important to view all of your dealings with clients in this respect. If you treat them like you would a friend, why wouldn't they become a friend?

7. Advertising, Marketing, and Promotion

Advertising, Marketing, and Promotion

The terms advertising, marketing, and promotion are often used interchangeably, but there is a difference between them. According to Webster's dictionary:

Advertising is announcing or praising a product or service in some public medium.

Promotion is the encouragement of the progress or growth or acceptance of something.

Marketing is the activities of a company associated with buying and selling a product or service.

In more basic terms, and as it relates to photography:

Advertising is bringing your service to the attention of potential clients, typically through signs, brochures, commercials, direct mailings, etc. It's a specific attempt to directly gain your client's attention.

Promotion keeps your services in the minds of your clients and helps to create demand. Advertising and public relations are ongoing components of promotion.

Marketing is the broadest range of activities involved in letting your clients know, overall, who you are, what you do, and what you can do for them. This can involve evaluating the competition, finding your market niche, and determining how to best price your services.

Creating a Marketing Plan

A marketing plan is a document that you create detailing exactly how you are going to get to your end goal in terms of your marketing objectives. You can find templates online or you can choose from a number of books out there about how to create a marketing plan. Even Microsoft Office (available for both Mac and PC) comes packaged with a marketing plan template! Basically, creating a comprehensive marketing plan can help you determine exactly how you might want to utilize advertising and promotions to meet your goals.

If you decide to create a five-year plan, it makes sense to keep this a living document by revisiting it annually and adjusting it based on how your business and goals are developing. Your business will change course and your desires for your business will evolve as you expand into new areas, scale back for family reasons, or find that your portrait business is through the roof and you need to open a second studio—or whatever changes come along over the years. If you revisit your plan on a regular basis, you will obtain a great deal more worth out of this valuable document.

As a bonus, if you ever decide to sell your business, an updated and clearly indispensible roadmap to the success of your studio's marketing will actually sell for real dollars as part of the overall transaction.

Deciding on the Type of Client

Deciding on the type of client you want to go after is really the first step to marketing effectively. Are you interested in marketing to a large school and gaining the contract to photograph a hundred children in an afternoon and then sell prints to all the parents? Or are you interesting in marketing to an upscale, dual-income family with the intention of photographing their two kids for two hours, then meeting with them afterward to manage the sale of goods? Decide this first, because that will make all the difference in how you position your services to the market. Many of the key questions you will want to address in your plan involve who you will be marketing to:

1. Who are my clients (an actual description of them)? What are their general demographics (age range, gender, socioeconomic status, etc.)?
2. How do I best target them?
3. What appeals to them?
4. What do they expect to spend? What are they open to spending?

In addition to these questions, you may also want to determine who else is marketing to the same demographic as your target market and see how you can either partner with them or align your interests in a way that can be mutually beneficial in the long run.

This component of your marketing plan can be as detailed or as general as you prefer. Just the exercise of creating this document will help to center your focus and really get you thinking about exactly the kinds of clients you want to attract to your business.

Reaching Out To Your Desired Client

There are so many ways to get the attention of your target market—once you decide on just who that target market is. One trick of the trade is to get very specific about who your dream client is. Let's imagine your dream clients are Teresa and her husband Andrew, along with their two kids Sophie and Caleb. You know that Teresa makes $75,000 a year and Andrew makes $110,000 a year. They live in that upscale neighborhood in town. She drives a two-year-old Honda Odyssey, and he drives a leased Audi sedan. Knowing this, you can start to think more about where they go, what they enjoy recreationally, what experiences appeal to them, and what they typically avoid in terms of purchases, sales tactics, and promo-

Deciding on the type of client you want to go after is really the first step to marketing effectively.

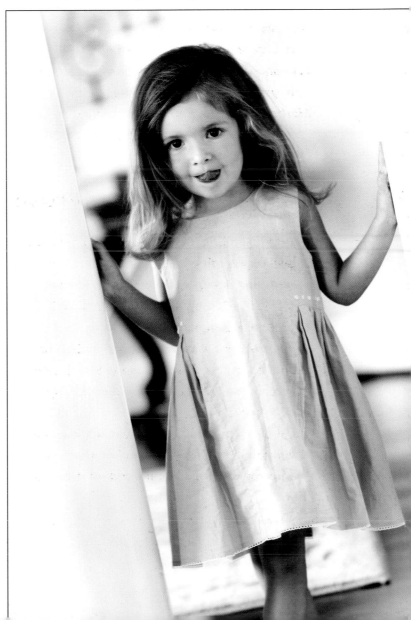

tions. With that in mind, the following are some ideas for how to reach Teresa and Andrew.

Word of Mouth. Word of mouth, also referred to as buzz marketing or viral marketing, is a huge marketing tool. It is so successful because it is widely perceived that this type of "advertising" about a brand is the most truthful. Getting people talking about your business in a positive way is the best way to attract new clients, because they come to you on their own. They have not been "sold" or targeted, they are just people who want to have the same positive experience as their friend, family member, neighbor, co-worker, fellow parishioner, or the person they overheard at the coffee shop—the person who they believe was simply speaking honestly and is unlikely to have an ulterior motive.

*The end of this cycle
is just the beginning
of a widening circle . . .*

So how do you get people talking about you? There are whole books written on the subject, but there are some key ways for photographers to get others talking about them. First, sign your work, so anyone who sees an image they like will immediately know that you created it. Mention your profession when you meet people, and refer to families you've photographed with the affection you feel for them. Part of buzz-building is creating something to talk about, igniting people's passion for the subject.

Blogging. You can also start and maintain an online community. Podcasts, message boards, forums, product reviews, and (most important for photographers) blogs are growing in popularity at an incredible speed. Online communities are particularly important today because the Internet is an increasingly accepted social medium. The photography community

is especially alive and active online, and blogs are a wonderful marketing tool to keep clients connected, get people talking, and showcase all your new work and exciting news. A blog, derived from the words *Web* and *log*, is a web site where entries are written chronologically in a journal format. Photographers' blogs can showcase images and the written word, or just images. It is also common in the profession to "micro-blog," a form of blogging that includes frequent entries that are shorter in length.

In addition to all the marketing and community-building perks, blogs also offer photographers an excellent opportunity to network with local stores and vendors. You can refer to favorite businesses in your blog posts and link to their sites, as well as requesting links from their sites to your blog and/or web site.

Advertising. *Print Media.* Consider placing an ad in a regional magazine with an image to showcase your style of work. Be sure to include your contact information. Think about what magazines Teresa is picking up and ascertain whether it is worth your dollars for the return.

Radio. Consider becoming a sponsor for a public radio station that appeals to your target market.

Online Media. You can also try placing an ad on a popular web site or search engine. This can be a banner ad on a popular parenting web site or a CPC (cost per click) ad on an online search engine, such as Google. You only pay for the ad if someone clicks on it, and you can place a maximum price on the ad (only $5.00/day, for instance).

Vendor and Retail Referrals. In addition to the great vendor and retail networking you can do via your blog, you can also receive direct inquiries from the clientele of a business by showcasing your work at their store or office. For example, you could showcase your work in a children's clothing store that caters to your target market, or at a doctor's office, or even in a coffee shop that is likely to be frequented by your target market. Just be sure that the venue matches the

market you want to reach or this type of approach could actually backfire. (For example, if you are trying to reach a demographic that does not shop at a particular poorly maintained discount store, prospective clients might reconsider your perceived value if they learn your work is being showcased there.) You can also strike up agreements with vendors to refer your work through their promotional materials by proposing exclusive offerings to their clients in return.

Promotional Materials. The types of promotional materials you use can include postcards, showcasing some of your imagery, that are displayed at various locations throughout your area, or business cards that are handed out liberally. With your logo and tagline prominently displayed on all stationary and packaging, these items also become promotional materials.

Direct Mail. Those same postcards that are on display throughout your area can also be repurposed as direct mail pieces. For these mailings, you can target certain neighborhoods (by zip code) that fit your demographic by purchasing address lists. Direct mail does not have to mean just postcards, though—you can narrow your focus and mail gift cards, small trinkets, or any promotional material you think might spark interest. One consideration with direct mail, however, is that eco-service companies are getting more sophisticated at ensuring unsolicited mail does not reach recipients, so do consider this before investing too much in a direct mail campaign. You may find that electronic efforts are less costly, better for the environment, and more effective to boot.

Networking. Networking means getting out and about. You need to meet the right people—people in the social circles you know that your ideal clients Teresa and Andrew are a part of. When you do, be sure to share your profession and work when it comes up naturally in conversation. Once you've made some new contacts, be sure to keep in touch with them.

Charitable Marketing. The charitable auction is alive and well in today's society, and it should not be

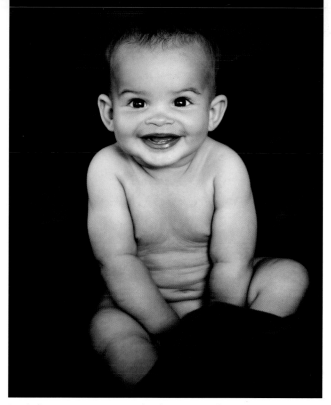

Look for opportunities to display some of your best images in places frequented by your target demographic.

ignored as an excellent opportunity to do some good with your talent, target-market Teresa and Andrew at their charity function of choice, promote your excellent work, be associated with a positive effort, and gain a new client (and an above-average sale with that client).

Charity auctions vary in format, but all are basically social functions designed to raise money for a certain cause—it could be as small as a fundraiser for a local preschool or as big as two thousand guests at a gala ball to promote the American Heart Association. Either way, you get involved by offering to donate a gift certificate for a certain amount—perhaps your session fee and a selected print, for example. In return, the auction organizers showcase a piece of your work and put out some of your promotional cards. Guests then mingle around the auction tables to bid. At these events, a variety of potential clients will take the time to examine your work, register your business name, and associate it with your imagery. Perhaps they will even pick up a promotional card or make a note to check out your web site. Often there

is a bidding war for your gift certificate, which is a simply fantastic buzz generator.

More often than not, the auction winner treats the money spent on your certificate as a charitable donation and regards it as separate from what she may want to spend on the lovely photographs you took of her children. (Interestingly enough, there is frequently a desire to purchase more than originally expected because of the "savings" of the gift certificate.) On top of this, you've built a new client relationship—as well as additional buzz with all the friends and family she proudly shows her proofs to, plus the friend who comes over a year later and sees your signed work on the wall. Oh—and you were also the catalyst for an additional $500 being donated to a great and worthy cause. Win, win, win.

You can hire a publicist
to get the word out about you,
or you can do it yourself.

Public Relations. You can hire a publicist to get the word out about you, or you can do it yourself. In essence, the point of public relations is to promote news about yourself, your company, your services, your products, etc. You can write and distribute press releases for free; there is literally no cost to you. Therefore this can be considered a form of guerrilla marketing. (*Note:* Now used as a catchphrase for low-budget marketing, the term "guerrilla marketing" actually comes straight from the title of a book written by Jay Conrad Levinson [Houghton Mifflin, 4th ed., 2007]. This book showcases marketing methods that rely on time, energy, and imagination more than big bucks. This can be a boon to an individual who has more time than money, but examine the suggested methods closely; some could be perceived as excessively aggressive.)

If you are looking for wide distribution of news that is more likely to be picked up by news outlets, consider working with a distribution service like PR Newswire, which will distribute your news as widely as you'd like and will also offer tracking services so you can see who picked up your release. One of the real goals of issuing a press release is to gain attention from media. Hopefully, they will contact you to learn more about you and your business—which of course leads to additional publicity.

Getting Published. Getting your photographs published in magazines or high-profile blogs can really bring a lot of attention to your business. First and foremost, it is a form of marketing that you can promote as well, through your web site, blog, bio, and other promotional outlets. But keep in mind that you are not just showing your work to potential clients, you are also showing your work to vendors who may call you to ask if you would like to display your work in their store. You are also showcasing your work to other magazines who might want to publish your work, too—which now creates a cycle that can add up to a lot of buzz and a steady supply of client bookings. There's also the very real benefit of enhancing your credibility. You can really never have too much credibility as you continue to establish and re-establish your brand. In addition, it's simply fun to see your work in print, and most people go into this business because it can plainly be a lot of fun.

Your Web Site. The role of the web site in a photographer's marketing toolkit has adjusted slightly as of late. For quite some time, it has been considered critically important to have a web site to showcase your gallery of work. It is still very important to have a web site, but many would argue that the blog is becoming even more important; it brings your work to life because it is constantly being updated. If your web site is your curb appeal (i.e., the front of your house and the actual street address), then your blog is where you really live—your home, the pulse of all the daily

activity. There's no doubt you need a strong, clean site to showcase your work, but this web site should thread visitors directly to your blog to keep them constantly coming back for more. Another option is to merge your blog and gallery onto one web site. This allows you to have one location for all your web traffic, so new visitors are always kept current.

E-Newsletters. An e-newsletter is an effective and inexpensive way to blast out important information, like promotions, deadlines, updates, and big news. There are a number of great companies out there who provide templates for e-newsletters that are highly customizable and allow you to track statistics, like click-through rates. This enables you to better tailor your messages to your audience.

Sponsorship Opportunities. Sponsoring an organization, publication, or event is an opportunity to basically exchange advertising (of your company) for either cash or trade of services. Depending on the target market of the group/event you are sponsoring, this can be a great vehicle to promote your business—or it can be virtually worthless.

The key here is to find out if this is something that Teresa and Andrew would be interested in supporting. One example might be offering to sponsor a local children's race. If it is a fairly well-known event and it takes place in one of your target neighborhoods—and maybe you are photographing children at the finish in exchange for your brand name on all the advertisements, t-shirts, and press releases—this could possibly be a good exchange for you.

Another form of sponsorship is straight donations, such as donating cash to a local arts venue or goodwill organization in exchange for recognition of your company's donation. Although this is certainly a form of marketing, straight donations may simply be more of a good deed as opposed to a huge marketing coup.

E-newsletters are a great way to share news with your clients.

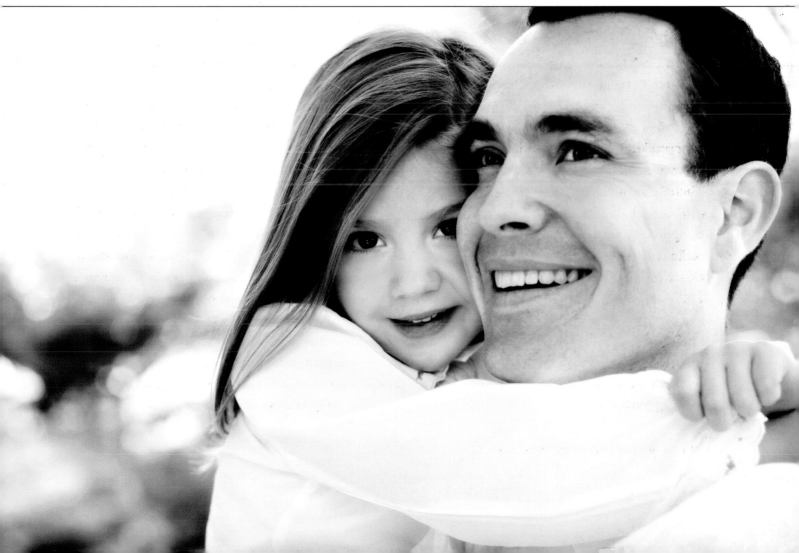

9. Pricing

Deciding on the Type of Business You Want

If you haven't firmly decided this already, you need to come to terms with the type of business you want to be running. Are you low-volume, high-pricing? High-volume, low-pricing? Or somewhere in the middle? There's no right or wrong answer here, but it is vitally important to know how you want to go after your market so that you can position yourself accordingly. The gorgeous high-end boutique up the street may have stunning window dressings and to-die-for products, but the discount clothing store on the other side of town may pull in triple the profits for selling significantly more clothing at less expensive prices. Just as there are a number of photographers who feel they want to reach more of the market by having more accessible pricing, there are just as many who want to manage the volume of their client base by taking more time with a lower volume of work.

Perceived Value in the Market

What are you telling potential clients about yourself by not saying anything to them at all? What is the general perception about you and your work in the marketplace—based on just your pricing?

It is always tricky to price your service or products, because the public perception of your pricing can help or hurt you just as much as their perception of the quality of your work. If you price your work too high, you may end up frustrating existing clients or turning off new ones; if you price your work too low, you may end up sending out a message that you aren't that "good."

How do your pricing and value line up in relation to each other?

When evaluating your pricing, know that price increases can be risky, but not moving pricing at all—staying too low—could be far more disastrous to your business image over the long term. So the question is, how do you raise prices without jeopardizing your overall sales revenues and, even worse, your profit margin? If the general rule of thumb is that raising prices will inevitably lose you some customers, how do you determine the percentage increase that will bring you a maximum return in profitability and a minimum hit in customer loss?

The first place to look is at your company's value proposition. That is, how do your pricing and value line up in relation to each other? More importantly, how is this proposition perceived in the marketplace?

You may get a general sense of this simply by the number of inquiries you are receiving, first of all, and the number of inquiries you are receiving that convert to booked shoots. Lastly, what are your sales averages after the shoot?

Another option is to survey lost clients or those potential clients who called to ask about your pricing but did not book a session. This does not have to be a big production, it can simply be a quick e-mail asking (in the friendliest manner) if there is any specific reason they chose not to book a session with you this time. You can learn a lot about your target market's perceptions of you and your business by just asking.

Using Sessions Fees as a Studio Scheduling Tool

Sometimes the best indicator that you need to raise your prices comes neatly wrapped up in the form of a jam-packed calendar. If you are booking out every possible time you can conceivably be working, chances are good that your session fee is too low.

Raising your session fee may lessen the number of shoots you book, but you can do some calculations to determine how much you can recover through a certain percentage increase in fees. By reviewing those calculations, you can quickly see that by doing less shoots for higher fees, you not only make up for the loss in shoots booked, you actually increase your revenue—and you find more time to improve your overall business by working/"producing" a bit less!

Cost of Goods and Cost of Time

What are your real costs and what are your real profits? Many photographers are surprised to learn that when they actually sit down and do the math, they are paying more in costs than they had originally estimated—especially when they add in the cost of their biggest asset: their valuable time.

If you want to run a truly profitable business, you should know exactly what it costs you to provide each product and service you offer. By most standards, you should try to keep your costs of goods to no more than 33 percent of the retail price.

And think about *all* of your costs, not just those associated with each sale. How much do you spend on overhead? Administrative costs? Those big-ticket expenses—the new projector or LCD, or that sweet new lens that was just released? How about dues to trade and/or professional organizations? Advertising,

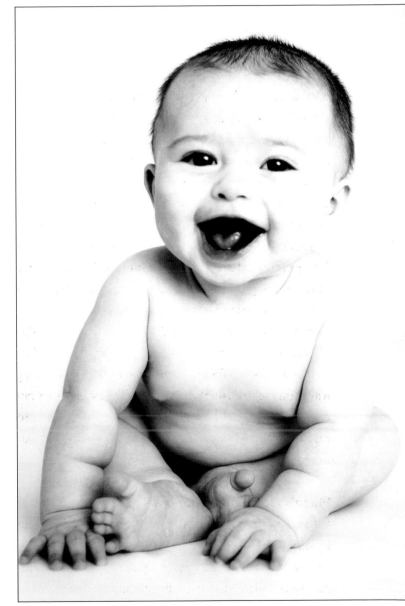

Price increases can be risky, but not moving pricing at all—staying too low—could be far more disastrous to your business in the long term.

marketing, and promotional materials? Credit-card processing fees? Photography contests? How about backup storage? Bank fees? CD cases? Software leasing costs? New backdrops? Hosting fees? Toilet paper, bottled water, your sound system??? There are so many costs, obvious and hidden, in the photography business. It is vital to track them all to get a real feel for what your expenses truly are.

Running your business based on costs of goods sold is only half the equation, though. You also need to factor in the cost of your time. How much is it costing you, in terms of your hourly rate, to produce each product? If you were to do something on your own, versus outsourcing the service to another vendor, would you be saving or losing money? Think about what you could be doing with your time if you did outsource a task. Would you be generating more revenue than it would cost you to pay for the task to be done?

Also consider what tasks you actually enjoy doing. A great exercise, and one that is clearly worth your time, is to make a list of all the tasks involved in the day-to-day operations of your business. Which of these tasks make you happy? Which are mindless and even frustrating? Which do you downright loathe? Now, what if you could reshape your job so that you loved all the tasks associated with it? What if those mindless or loathsome activities could be completely outsourced? Maybe it would cost you $30/hour to hire a bookkeeper, but hopefully you'd be bringing in three times that amount by shooting portraits instead. So does that make your time worth $100/hour? And how does the cost of your time factor into your overall pricing structure?

If it costs $2.00 to print a 5x7, but if it takes ten minutes of your time for final edits and ordering, and another five minutes to package it up, and the packaging alone is another $1.60, that $2.00 print is now running at around $30 in costs to you! And now you have to multiply that dollar figure based on a 33 percent cost-of-goods rate . . . So what are you charging for that 5x7?

How much is it costing you, in terms of your hourly rate, to produce each product?

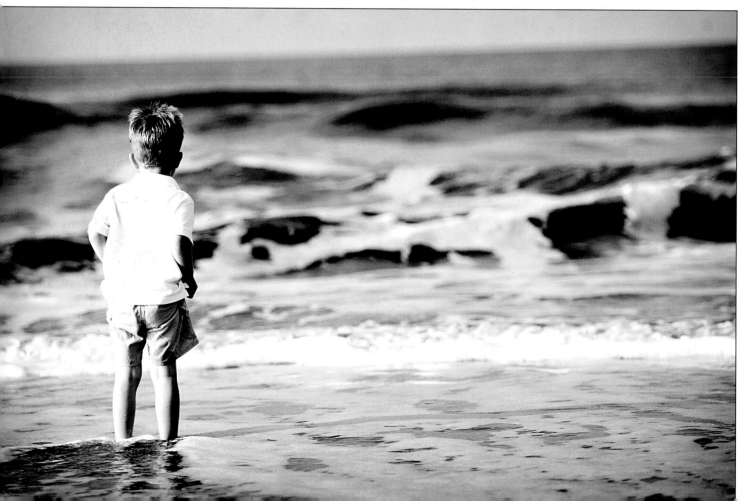

9. To Sum Up

Staff Relationships: Internal and External

You may be a sole proprietor, running every facet of your business on your own, or perhaps you have an assistant helping out with the administrative needs. Or maybe you have a full-time studio director, two assistants and ten associate photographers working for you. Whatever your business model, you have staff. You have someone helping you somewhere—even if it's just the mail carrier bringing your checks.

External. Let's look at external staff first. One of the smartest ways to grow your business is to align yourself with the best in the business. A wonderful aspect of this industry is that the smallest revenue generator out there has the opportunity to order a canvas piece from the same company that provides products to the highest revenue generator in the business. This is not true of all industries, and it's a huge plus for those entering the photography business or those looking to find new vendors.

What this means for you may be different from what it means for your competitors, but the best way to decide on whom to work with is to decide what is important to you as a business owner. When deciding on a lab, for instance, are you most concerned about the quality of the print, their level of customer service, the ability of the lab to make color corrections, specific art retouching, or the speed of their shipping? Start with what you know you need in a partner, research the names out there that are receiving their own great word of mouth, and then proceed to cultivate that relationship.

One of the smartest ways to grow your business is to align yourself with the best in the business.

After you establish a mutually beneficial alliance, treat these treasured vendors with the respect they deserve. Your contact at that lab in Missouri is the one who is going to push a rush print for you in an emergency situation, and your service rep at that framing company in Georgia is the one who will oversee a quick custom build for you when you made the mistake of not placing the order in time. These companies, and the individuals within these companies with whom you build relationships, are absolutely an extension of your business. If you are not thinking of them in those terms, you are missing out on an opportunity to grow a stronger, more connected business. Of course, if you are not receiving the same level of respect from them in return, then you may want to seriously consider looking elsewhere.

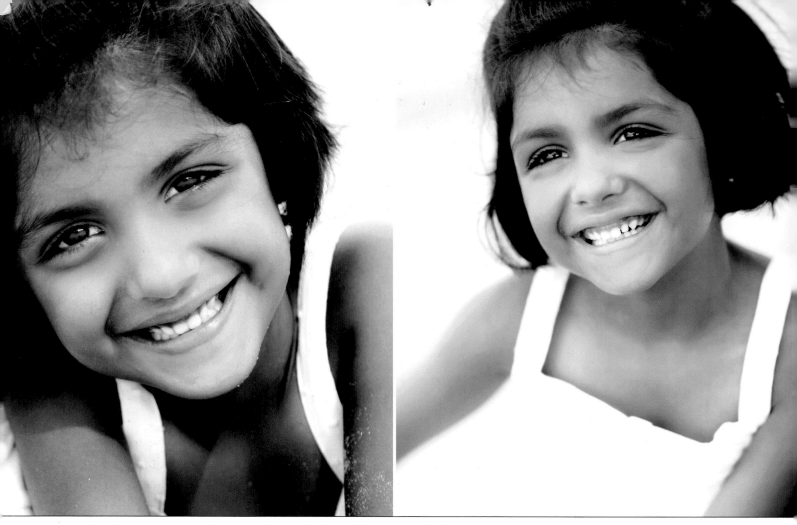

Creating a pleasant environment at your studio benefits everyone in the long run.

Internal. Next there is internal staff. People who help you, who are smart, who care, and who are good at their jobs are worth their weight in gold. Pay them what you think they deserve, not just the least you can get away with. Turnover costs you time, energy, money, and stress.

You will not keep your favorite employees forever—people move, family situations change, and photographers burn out for good. This will happen despite your most well-intentioned efforts. But if you can keep your best talent on board by treating them like the valuable employees they are, by expressing your appreciation for them, and by creating a pleasant environment for them, you will be doing everyone a favor in the long run. Keep in mind that employees are also ambassadors of your work; they create buzz with everyone they come into contact with. If they

ever do leave, you want their experience to have been a positive one. It's surprising what a little bad blood can do when it is attached to a small business.

Mistakes Can Make You Stronger (But Go Ahead and Avoid These Specific Ones)

James Joyce wrote that, "Mistakes are the portal of discovery." Yes, I made a great many mistakes when I started my business—and even more of them years down the road. I have learned so much from those mistakes that my portal of discovery has been quite wide! But I have also learned that there were many mistakes I made that I would have happily have skipped over if I had been armed with enough foresight. Many mistakes took just a moment; others were repeated daily for years. I offer you now just a few nuggets of hard-earned wisdom.

The Family Reunion that I (Nearly) Ruined. I had booked a session for a large family reunion. About thirty-five members of this family were all gathering under one roof for Thanksgiving, and that would be the only day they were all together at the same time. It had been over ten years since their last gathering and it would be many more before they planned to meet again. The person who booked the shoot explained that they had so little time together, they were not completely sure they wanted to take the time for a shoot. Still, they knew it was important to document the gathering, so the compromise was to ask me to come to their home for a "fast" family portrait. Note that they booked me specifically because they had heard that I worked quickly and made it a painless, even fun experience. They paid an additional session fee for the extended family, in addition to an out-of-area travel fee. I'd be in and out, and they had already told me they'd have a large order. Sounds good so far, right?

My family and I happened to be driving right by this town on our way to visit relatives for the holidays. Since it would be such a quick shoot, they drove me there and planned to just do a little shopping for the short time I'd be gone—and then we'd be on our way. So they dropped me off at the century-old home, and I brought a couple of strobes in with me to help me properly light the large group. But what I didn't bring was a backup camera. Back then I had been downright lazy about backup equipment. I knew it was considered an important thing to do, theoretically, but I'd never experienced an incident with equipment failure, so sometimes I brought backup . . . and sometimes I just didn't.

The shoot started out easily enough. I meandered about capturing some candid moments until we decided to bring everyone together for the big photograph. Without even considering the age of the home or the electrical system, I plugged in my two strobes after positioning them as best I could to light the extended family. I connected my digital camera to the strobes, as I wasn't using a wireless transmitter yet, and I took two quick test shots. All was looking good, so I rattled off a few quick tips to the group about basic posing and proceeded to start the shoot. Nearly instantly, the camera displayed an error code and surged off, while the light sputtered and made a popping sound that did not sound good. Apparently, I had received too strong a surge from their antiquated electrical system and I not only blew out a light, I blew out my camera, too. I had even fried the CompactFlash card. I couldn't even pretend that nothing had happened. Something had clearly happened. And there I was with a bum light, no backup camera, and thirty-five people looking at me expectantly.

I called my husband and asked him to drive forty-five minutes in the opposite direction to get my backup camera and return as quickly as he could, so that I could get that shot. For nearly an hour and a half, I lurked about here and there, muttering sincere apologies and feeling very much the outsider—the intruder on their special gathering.

I not only blew out a light, I blew out my camera. I had even fried the CompactFlash card.

Once the new camera was finally brought back, I re-collected the entire group and did my very best to light them with all the available light in the living room (all the lamps on with their lampshades off, every curtain wide open, tucked behind available furniture). The one saving grace was that it was also now the brightest part of the day.

By the time I finally skulked out of there, I'd spent nearly two-and-a-half hours shooting a gathering that was going to take me forty minutes at the very most. I had provided the opposite of the service that I had

been hired to deliver. I felt like an idiot, and I'd taken quite a financial hit by ruining some very expensive equipment.

With incredible effort in editing, I was able to salvage those family portraits to actual presentable proofs. Not surprisingly, I gave them several wall portraits as gifts, with my most sincere apologies, and they even ended up placing a solid order. All things considered, they were exceptionally kind about the entire experience—but they are one of the few clients I have photographed that I never heard back from again.

Lessons Learned: Always bring backup equipment for everything. And pay special attention to the electricity you are using. Bring a surge protector with you for your lighting equipment. If the setup still looks at all questionable (even with surge protection) strongly consider an alternate lighting plan.

The Family Portrait that I Missed, Rescheduled, Then Lost. I had booked a family portrait several months in advance, and we touched base two weeks prior to confirm the time and place to meet. Between our confirmation and the actual date of the shoot, we lost power in our house for about twenty-four hours due to an electrical storm.

I had been in the habit then of only looking at my

> *By the time I turned my phone on and heard their messages, my heart just sank.*

electronic calendar in the morning, to see what was on the schedule that day, with no real idea of what to expect prior to each morning's review. Since we didn't have power, I wasn't able to check my calendar that day and couldn't remember if I had something booked. Well, I did. I had a family portrait booked, and when they called me repeatedly over the course of an hour from that park where we were supposed to

meet, my phone was turned off—something I used to do quite often so I could focus on editing.

By the time I turned my phone on and heard their messages, my heart just sank. I called and apologized profusely, although I had no good excuse to offer them. I had simply forgotten that I'd booked their session that day, and I didn't have an alternate calendar to check when I couldn't access my computer. This is the first and last time I have ever forgotten about a shoot. The first because I was usually diligent about confirming my schedule, and the last because I put some serious checks and balances in my business flow to confirm that this would never happen again. I didn't like how it felt—to them or to me.

We rescheduled their shoot for a few days later, and I showed up knowing that I had some serious ground to make up for, given their experience to date. We were luckily able to work through the awkwardness quickly, and their daughter was just a joy to photograph. We parted ways after a long, successful shoot, and I left them with the promise that I would give them all the images on DVD to print as they wished, a rare offering.

Having made the best of a bad situation, I was finally feeling better when I started downloading my cards onto my hard drive. Feeling good, that is, until I saw a stark error message warning me that I had ejected a drive and that I was in danger of corrupting or losing the data on that drive. I looked down and saw that I had ever so slightly elbowed the card-reader wire in a way that had pulled it away from the computer. In a near panic, I quickly jammed the cord back into the hard drive, but it was already too late. There was no data on the card at all, and only three images had downloaded. I put the card back in the camera, and it told me that the card was empty. I ran the data recovery program that came with the card, but it was not successful. I ran it twice more just in case.

I just couldn't go back to this family again with more bad news. In the end, I tracked down a data re-

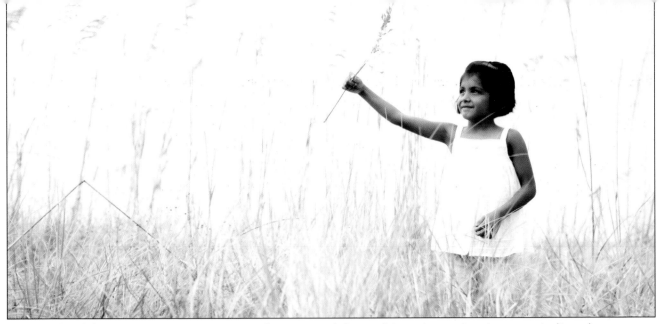

When I realized that I was missing out on projected revenue goals by not doing sales sessions in person, I adjusted my process.

covery service in Chicago and mailed the card there, paying a $275.00 fee for their efforts. They did recover the data that was not accessible to me, and I was thrilled to receive the images back on CD.

Lessons Learned: Confirm shoots the day before they are scheduled and/or even the day of, when possible. Things change, people get sick, weather shifts, and sometimes you just don't remember appointments. Locking in a process that prompts you to confirm shoots daily will go a long way toward preventing such an occurrence. Also, secure your data retrieval process. Maybe it's as fundamental as taping down your connecting cord, maybe it's investing in wireless transmission—and certainly it is working with only the best and most tested memory technology and continually investing in the best data-recovery programs. And, of course, it's always about backing up your schedule and your work.

The Revenue I Missed by Not Meeting with Clients. This was not as dramatic an experience as the previous two, but rather a mistake I made day after day for years. Basically, I did not meet with clients after the shoot. I actually would not meet with clients after the shoot unless I was *really, really* pushed to do so. My day-to-day process was to fill up my schedule with so many shoots that all I could do was turn them around, post them online for proofing and collect the orders as they came in—whatever they might be. My philosophy was that I was simply too busy doing all those shoots to actually meet with anyone.

One month, after a few requests in a row to meet, I started noticing a serious upward trend in the average revenue per shoot when I did get "forced" into a meeting. This prompted me to finally put together a spreadsheet to forecast just how much revenue I might be forsaking by continuing my no-meetings policy. When I started laying out all the details, I was able to really hone in on the fact that the significant majority of revenue came from what happened *after* the shoot. Although the session fees mattered for a variety of reasons, they didn't compare to revenue gained afterward. Needless to say, I adjusted my process to what it is today, and it has even exceeded my initial expectations—not only in the significant increase in overall revenues, but also in the enhanced client relationships and genuine friendships I have been lucky to solidify over time.

Lessons Learned: The bulk of the work is in shooting and editing the images. By not meeting with clients and walking them through all the possibilities, you lose the opportunity to capitalize on the effort already put forth. The session fees are not where your long-term revenue lies.

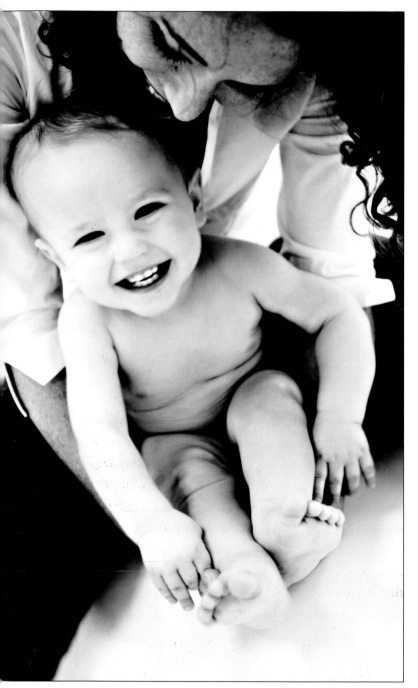

Become an observer of the images all around you and use what you see to inspire your own work.

Staying Current in an Ever-Changing Industry

One of the huge upsides of being a photographer is that while keeping current may be work (it takes time and you have to stay on top of it in this ever-changing industry), it is also a treat. Photographers love to look at imagery—our own work, work by photographers who inspire us, and of course the plethora of imagery that is readily available to us in the media, both fashion and editorial. We are surrounded by images every day and much of the job of keeping current can be done by simply paying attention.

Becoming involved with photography message forums can be hugely beneficial to your career. While it certainly may seem difficult to keep pace with those who post all the time, you can participate as you are able and you will certainly learn so much from the interactions. There are a great many online communities out there that provide invaluable data, a unique kinship, and oftentimes the most current information about just where this industry is going. Simply by keeping up with the threads in these forums, you can get a solid feel for the trends as they come and go— and you gain valuable insight as to what's on the horizon (as documented by Lisa in San Francisco) and what's *so* yesterday (according to Jim in Melbourne).

Making the time to attend the latest seminars and conventions is always helpful—not just for what you may learn, but also because they give you time to focus on your craft and your business strategy while unencumbered by your "regular work." When selecting what seminars or conventions to attend, don't judge their importance simply by your impression of the imagery. A photographer may not practice your preferred shooting style, but that doesn't mean he won't have some excellent business advice to offer.

You can also stay current by simply flipping through fashion magazines at the local magazine stand or grocery store. You'll notice that it seems like textures on images are everywhere, or the hottest magazines are showcasing a noticeable drift toward highly stylized editorial shoots. Just like sepia was all the rage not too long ago, you'll get a strong feel for what is coming down the pike in media—just by looking and staying focused. Whether you, as a photographer, choose to take part in those trends is entirely up to you. If it seems exciting and interesting and some-

thing you want to be a part of, well, that's one of the best parts of this job (one of the many!). You might even find enough inspiration to start a global movement yourself.

Keeping *You* Authentic

The word *authentic* is defined as truthful and real or original. Those are good words, but actually living authentically is a little more complex. If you already are a busy portrait shooter, you know how difficult it can be to stick to the truth with every session you do, to keep things fresh and allow them to unfold as naturally as possible. When you hit the real busy season and are shooting sessions daily and you sit down to another family staring back at you blankly, literally saying "Tell us what to do!", it can take a lot of effort to create an atmosphere where you are capturing them as the family they are and not just setting them up in a pose or situation that has worked for you a hundred times in the past.

Keeping your work authentic can be a daily task. And keeping *you* authentic may take even more effort. The enemy of the busy-but-authentic creative professional is exhaustion. Exhaustion leads to burnout and burnout leads to apathy. And how can you stay passionate about your life and your work when you start feeling dangerously close to indifferent about it all?

Part of what you take on by working in a clearly creative profession is the energy of the subjects with whom you connect through these portrait sessions. It is arguable that the more tuned-in you are to your subjects' feelings and reactions, even the most subtle nuances, the better you will be as a photographer. That entails a whole mess of energy going around between you, your subjects, and your work—and you are receiving all kinds. Certainly you are receiving some negative energy (waiting out a toddler's tantrum), and you are no doubt pushing out plenty of positive energy (smiling, upbeat, and how many times do you find yourself making this face or that face, or even concentrating on making no face?). On top of it all, you're meeting new people all the time, which also requires you to be turned to "on" for the vast majority of your day.

So when you have a packed schedule, and you are giving your all to each one of these sessions and every one of those thousands of little interactions, it's easy to find yourself feeling some serious exhaustion, both emotionally and physically. If you keep that pace up and ignore the need for an outlet of some kind, you'll most certainly find that exhaustion converting into a whole lot of burnout, as well as a certain sense of disillusionment about the entire profession, not to mention your place in it.

As someone who is engaged in expressive work, you are even more susceptible to burnout because you are often an integral part of an emotionally intense activity, and you inevitably suffer the stress of ongoing, multiple deadlines.

Happily, there are a good number of ways to guard against this pitfall. The simplest method is to stay on top of your schedule, manage your workflow carefully, and don't over-promise. But what about during the busy seasons? What about when it is four weeks to Christmas and it seems like everyone in your state wants a holiday card, fourteen framed pieces, and two albums—and they're going to need it next week, thank you very much?

Stay on top of your schedule, manage your workflow carefully, and don't over-promise.

This is when it becomes critical to engage in energy-releasing activities. A regular fitness regime is a near must, not only for stress management, but also for mood-boosting—and of course to keep you fit enough to keep up with the crazy little humans that

you chase down with camera in hand. There's fantastic research that speaks to exercise as a proven means to keeping depression at bay. And, let's face it, burnout can mirror depression in a lot of ways.

The more you are able to deepen your focus, the more creative you can become.

Eating healthfully will also make an enormous difference in how you feel, and staying connected to friends and family will bring you great comfort. Another fantastic practice for creative professionals is meditation. Although meditation is widely recognized way to control stress and manage burnout, some still view it as a new-age phenomenon instead of a very real health protector. Meditation is basically a conscious effort to turn off the outside world and concentrate your focus inward. There are a number of mediation exercises, many of which deal with visualization and clearing out the litany of obligations that blast across your brain on a perpetual basis. It's an opportunity to "re-boot" yourself and release pent-up frustration, anxiety, and even exhaustion.

Many of these visualization techniques tend to really appeal to imagery-centered individuals, like photographers. In fact, whenever we tune in to our creative energies, we are approaching the essence of a meditative state. This explains the "zone" a lot of photographers slip into when very focused on editing their work. There's an argument that the more you are able to deepen your focus, the more creative you can become—and the practice of meditation, or just mindful relaxation, can enable you to enhance your concentration, allowing for even more joy in the authenticity of your work and bringing more peace to your every day life.

In Conclusion . . .

The following are a few things to consider about photography and your life as a photographer:

1. Know that you will nearly always overestimate yourself and underestimate your workload. The sooner you can balance this, the better.
2. Don't try to be like anyone else. This is true in life as well as in photography. The style that you are meant to show to the world will only come from you. Let it naturally evolve. Stay honest in your work and with your clients.
3. Show what you love. Edit out the rest.
4. If you wish you had something more than five times, something you know would improve your business, your style, or your appreciation for your own art, acquire it and use it to continue to grow. You feel that push because it is important. Listen to you.
5. Stay calm with clients. You can jump and be crazy and giggle like a three-year-old during your shoots, but strive to stay calm and professional in all of your business dealings.
6. Take exceptional care of your photography equipment. Keep everything spotless.
7. Be genuinely grateful for your clients, and express your sincere appreciation for their business. They are the reason you are compensated for the amazing work you do.
8. Prepare for every shoot like it is the most important shoot you'll ever do. Charge everything; check your equipment. Be confident that your backup gear is in working order.
9. The only person who can limit you and your career is you. Do not set limits on what you can achieve and who you can be become. What you can accomplish is unimaginable—but only until you imagine it.
10. Love this job. It is such a gift to work with innocence, beauty, light, and honest emotion.

Thank You

There are so many people that I could thank—I finally have a glimpse into the pressure of winning an Oscar. But I will keep it easy and just thank my immediate sphere of family. All others simply must know that I am grateful.

I want to thank my daughter, Sophie, who brought such an incredible joy to my life from the moment I knew she would be born. I love you with a passion that prompts you to sigh with exasperation, "Too much love, Mommy. Hugs need a break, too." You are so unbelievably funny. You are sunshine and light and sweetness, and I am overcome with delight when I look at you, my treasured daughter.

I want to thank my son, Caleb, who transforms a room with his smile. I love your focused intensity, your passion for all things vehicular, and the uncommon way you seek your peace. I love how you laugh so hard you fall down. And then you do it again. You adore your daddy like the superhero he is, and you are kind enough to offer me a cape so that I can fly with you, too. I am honored to spend my life as your mom.

I want to thank my husband, Steve, who simply has to have been assigned to me through lifetimes and lifetimes. You are my best friend, and not just in the flippant use of the term—you embody the best part of friendship to me, and I have never shared more with another. You somehow become a better man each day, and you give the best hugs. You are the person I trust most, the one I am genuinely excited to date so often. Thank you for being my sweet, loving, beautiful husband. Thank you for being such an outstanding father to our children. Thank you, thank you, thank you. I could never express enough appreciation for you.

Index

WEDDING PHOTOGRAPHER'S HANDBOOK

Bill Hurter

Learn to produce images with technical proficiency and superb, unbridled artistry. Includes images and insights from top industry pros. $34.95 list, 8.5x11, 128p, 180 color photos, 10 screen shots, index, order no. 1827.

RANGEFINDER'S PROFESSIONAL PHOTOGRAPHY

edited by Bill Hurter

Editor Bill Hurter shares over one hundred "recipes" from *Rangefinder's* popular cookbook series, showing you how to shoot, pose, light, and edit fabulous images. $34.95 list, 8.5x11, 128p, 150 color photos, index, order no. 1828.

SIMPLE LIGHTING TECHNIQUES
FOR PORTRAIT PHOTOGRAPHERS

Bill Hurter

Make complicated lighting setups a thing of the past. In this book, you'll learn how to streamline your lighting for more efficient shoots and more natural-looking portraits. $34.95 list, 8.5x11, 128p, 175 color images, index, order no. 1864.

MASTER LIGHTING GUIDE
FOR WEDDING PHOTOGRAPHERS

Bill Hurter

Capture perfect lighting quickly and easily at the ceremony and reception—indoors and out. Includes tips from the pros for lighting individuals, couples, and groups. $34.95 list, 8.5x11, 128p, 200 color photos, index, order no. 1852.

PHOTOGRAPHER'S GUIDE TO WEDDING ALBUM DESIGN AND SALES, 2nd Ed.

Bob Coates

Learn how industry leaders design, assemble, and market their albums with the insights and advice in this popular book. $34.95 list, 8.5x11, 128p, 175 full-color images, index, order no. 1865.

LIGHTING FOR PHOTOGRAPHY TECHNIQUES FOR STUDIO AND LOCATION SHOOTS

Dr. Glenn Rand

Gain the technical knowledge of natural and artificial light you need to take control of every scene you encounter—and produce incredible photographs. $34.95 list, 8.5x11, 128p, 150 color images/diagrams, index, order no. 1866.

SCULPTING WITH LIGHT

Allison Earnest

Learn how to design the lighting effect that will best flatter your subject. Studio and location lighting setups are covered in detail with an assortment of helpful variations provided for each shot. $34.95 list, 8.5x11, 128p, 175 color images, diagrams, index, order no. 1867.

MASTER'S GUIDE TO WEDDING PHOTOGRAPHY
CAPTURING UNFORGETTABLE MOMENTS AND LASTING IMPRESSIONS

Marcus Bell

Learn to capture the unique energy and mood of each wedding and build a lifelong client relationship. $34.95 list, 8.5x11, 128p, 200 color photos, index, order no. 1832.

MASTER LIGHTING GUIDE
FOR COMMERCIAL PHOTOGRAPHERS

Robert Morrissey

Use the tools and techniques pros rely on to land corporate clients. Includes diagrams, images, and techniques for a failsafe approach for shots that sell. $34.95 list, 8.5x11, 128p, 110 color photos, 125 diagrams, index, order no. 1833.

STEP-BY-STEP WEDDING PHOTOGRAPHY

Damon Tucci

Deliver the top-quality images that your clients demand with the tips in this essential book. Tucci shows you how to become more creative, more efficient, and more successful. $34.95 list, 8.5x11, 128p, 175 color images, index, order no. 1868.

PROFESSIONAL WEDDING PHOTOGRAPHY

Lou Jacobs Jr.

Jacobs explores techniques and images from over a dozen top professional wedding photographers in this revealing book, taking you behind the scenes and into the minds of the masters. $34.95 list, 8.5x11, 128p, 175 color images, index, order no. 2004.

STUDIO PORTRAIT PHOTOGRAPHY OF CHILDREN AND BABIES, 3rd Ed.

Marilyn Sholin

Work with the youngest portrait clients to create cherished images. Includes techniques for working with kids at every developmental stage, from infants to young school-age kids. $34.95 list, 8.5x11, 128p, 140 color photos, order no. 1845.

50 LIGHTING SETUPS FOR PORTRAIT PHOTOGRAPHERS

Steven H. Begleiter

Filled with unique portraits and lighting diagrams, plus the "recipe" for creating each one, this book is an indispensible resource you'll rely on for a wide range of portrait situations and subjects. $34.95 list, 8.5x11, 128p, 150 color images and diagrams, index, order no. 1872.

DIGITAL PHOTOGRAPHY BOOT CAMP, 2nd Ed.

Kevin Kubota

This popular book based on Kevin Kubota's sellout workshop series is now fully updated with techniques for Adobe Photoshop and Lightroom. It's a down-and-dirty, step-by-step course for professionals! $34.95 list, 8.5x11, 128p, 220 color images, index, order no. 1873.

100 TECHNIQUES FOR PROFESSIONAL WEDDING PHOTOGRAPHERS

Bill Hurter

Top photographers provide tips for becoming a better shooter—from optimizing your gear, to capturing perfect moments, to streamlining your workflow. $34.95 list, 8.5x11, 128p, 180 color images and diagrams, index, order no. 1875.

BUTTERFLY PHOTOGRAPHER'S HANDBOOK

William B. Folsom

Learn how to locate butterflies, approach without disturbing them, and capture spectacular, detailed images. $34.95 list, 8.5x11, 128p, 175 color images, index, order no. 1877.

500 POSES FOR PHOTOGRAPHING WOMEN

Michelle Perkins

A vast assortment of inspiring images, from head-and-shoulders to full-length portraits, and classic to contemporary styles—perfect for when you need a little shot of inspiration to create a new pose. $34.95 list, 8.5x11, 128p, 500 color images, order no. 1879.

POWER MARKETING, SELLING, AND PRICING

A BUSINESS GUIDE FOR WEDDING AND PORTRAIT PHOTOGRAPHERS, 2ND ED.

Mitche Graf

Master the skills you need to take control of your business, boost your bottom line, and build the life you want. $34.95 list, 8.5x11, 144p, 90 color images, index, order no. 1876.

MINIMALIST LIGHTING

PROFESSIONAL TECHNIQUES FOR STUDIO PHOTOGRAPHY

Kirk Tuck

Learn how technological advances have made it easy and inexpensive to set up your own studio for portrait photography, commercial photography, and more. $34.95 list, 8.5x11, 128p, 190 color images and diagrams, index, order no. 1880.

CHILDREN'S PORTRAIT PHOTOGRAPHY HANDBOOK

Bill Hurter

Packed with inside tips from industry leaders, this book shows you the ins and outs of working with some of photography's most challenging subjects. $34.95 list, 8.5x11, 128p, 175 color images, index, order no. 1840.

MASTER POSING GUIDE FOR WEDDING PHOTOGRAPHERS

Bill Hurter

Learn a balanced approach to wedding posing and create images that make your clients look their very best while still reflecting the spontaneity and joy of the event. $34.95 list, 8.5x11, 128p, 180 color images and diagrams, index, order no. 1881.

ELLIE VAYO'S GUIDE TO
BOUDOIR PHOTOGRAPHY

Learn how to create flattering, sensual images that women will love as gifts for their significant others or keepsakes for themselves. Covers everything you need to know—from getting clients in the door, to running a succesful session, to making a big sale. $34.95 list, 8.5x11, 128p, 180 color images, index, order no. 1882.

MASTER GUIDE FOR
PHOTOGRAPHING HIGH SCHOOL SENIORS

Dave, Jean, and J. D. Wacker

Learn how to stay at the top of the ever-changing senior portrait market with these techniques for success. $34.95 list, 8.5x11, 128p, 270 color images, index, order no. 1883.

THE SANDY PUC' GUIDE TO
CHILDREN'S PORTRAIT PHOTOGRAPHY

Learn how Puc' handles every client interaction and session for priceless portraits, the ultimate client experience, and maximum profits. $34.95 list, 8.5x11, 128p, 180 color images, index, order no. 1859.

PHOTOGRAPHING JEWISH WEDDINGS

Stan Turkel

Learn the key elements of the Jewish wedding ceremony, terms you may encounter, and how to plan your schedule for flawless coverage of the event. $39.95 list, 8.5x11, 128p, 170 color images, index, order no. 1884.

AVAILABLE LIGHT
PHOTOGRAPHIC TECHNIQUES FOR USING EXISTING LIGHT SOURCES

Don Marr

Don Marr shows you how to find great light, modify not-so-great light, and harness the beauty of some unusual light sources in this step-by-step book. $34.95 list, 8.5x11, 128p, 135 color images, index, order no. 1885.

JEFF SMITH'S GUIDE TO
HEAD AND SHOULDERS PORTRAIT PHOTOGRAPHY

Jeff Smith shows you how to make head and shoulders portraits a more creative and lucrative part of your business—whether in the studio or on location. $34.95 list, 8.5x11, 128p, 200 color images, index, order no. 1886.

THE PHOTOGRAPHER'S GUIDE TO
MAKING MONEY
150 IDEAS FOR CUTTING COSTS AND BOOSTING PROFITS

Karen Dórame

Learn how to reduce overhead, improve marketing, and increase your studio's overall profitability. $34.95 list, 8.5x11, 128p, 200 color images, index, order no. 1887.

ON-CAMERA FLASH
TECHNIQUES FOR DIGITAL WEDDING AND PORTRAIT PHOTOGRAPHY

Neil van Niekerk

Discover how you can use on-camera flash to create soft, flawless lighting that flatters your subjects—and doesn't slow you down on location shoots. $34.95 list, 8.5x11, 128p, 190 color images, index, order no. 1888.

PROFESSIONAL CHILDREN'S PORTRAIT PHOTOGRAPHY

Lou Jacobs Jr.

Fifteen top photographers reveal their most successful techniques—from working with un-cooperative kids, to lighting, to marketing your studio. $34.95 list, 8.5x11, 128p, 200 color photos, index, order no. 2001.

LIGHTING TECHNIQUES
FOR PHOTOGRAPHING MODEL PORTFOLIOS

Billy Pegram

Learn how to light images that will get you—and your model—noticed. Pegram provides start-to-finish analysis of real-life sessions, showing you how to make the right decisions each step of the way. $34.95 list, 8.5x11, 128p, 150 color images, index, order no. 1889.